M000215272

IMAGES
of America

RIVER GROVE

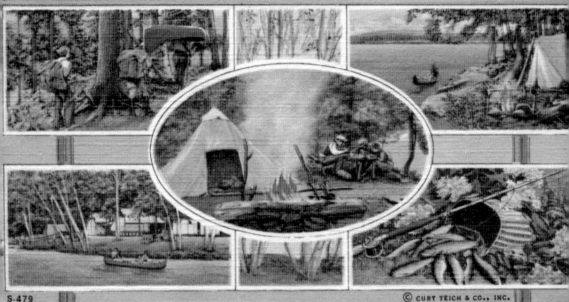

Greetings from **RIVER GROVE, ILL.**

S-479 © CURT TEICH & CO., INC.

This postcard, extending greetings from River Grove, is an example of a standard card that could be personalized for almost any community bordering a river. The Des Plaines River flows through the center of River Grove like a major artery pumping life and adventure through the souls of the young and young at heart. Somewhat clichéd, this postcard still resonates with those who have spent hours walking, riding the trails, fishing, or catching crayfish at the frog pond. (Author's collection.)

ON THE COVER: Fr. John Schiffer (far left) along with Henry Buckman (on ladder) are seen with the men who cleared the land for St. Joseph's Cemetery The land was purchased in 1901 by the Guardian Angel Orphanage, which was an organization founded by German Catholics. A good portion of land had previously been part of the LaFramboise reserve and was extensively wooded with native growth. (River Grove Historical Commission.)

IMAGES
of America

RIVER GROVE

Kenneth J. Knack
Foreword by Mario L. Novelli

ARCADIA
PUBLISHING

Copyright © 2018 by Kenneth J. Knack
ISBN 978-1-4671-2973-2

Published by Arcadia Publishing
Charleston, South Carolina

Printed in the United States of America

Library of Congress Control Number: 2018938240

For all general information, please contact Arcadia Publishing:
Telephone 843-853-2070
Fax 843-853-0044
E-mail sales@arcadiapublishing.com
For customer service and orders:
Toll-Free 1-888-313-2665

Visit us on the Internet at www.arcadiapublishing.com

*To my wife Diane, thank you for your love and
support—we made it through another one!*

*Also, to the people of River Grove, past and present,
for creating a wonderful community.*

CONTENTS

FOREWORD

River Grove has been home sweet home to five generations of my family. Being asked to pen this foreword has rekindled many wonderful memories of "the Village of Friendly Neighbors," which will forever live on in my mind. Don't be surprised if they spark a few of your own also!

Memories include riding bicycles down dirt trails along our stretch of the Des Plaines River, peddling past horseback riders as they followed the bridle path, on their way to and from Sunset Farms riding stable; a cool drink during a hot day of playing lob-league baseball at Peterson's Field via a few hand-operated water pumps in the woods (although everyone tried to avoid the one that tasted like egg-water); looking for toads or turtles at "the Frog Pond"; pickup hockey games at National Field on an impromptu ice rink provided by the village in winter; scratching up 15¢ for a cherry-cola "phosphate" and a bag of chips at the soda fountain of Johnson's Drugstore; a small toy catching your eye at the dime store known to everyone in town simply as "Hanks"; walking through the gravel alley behind Liborio's bakery to the aroma of fresh bread and pizza wafting through the breeze; knowing that when our fire department's "Six O'clock Whistle" wailed its long single blast, you'd better skedaddle home for dinner (who needed a cell phone?); and watching the trains that ran along the Milwaukee Road line, waving to the engineer, who would in turn wave back. Etched in my mind are glimpses of the cattle, sheep, and other livestock peering out through the wooden-slatted cars as they headed east towards the Chicago Stockyards. Feed grain would occasionally be jostled out, and it wouldn't be uncommon to see volunteer corn plants growing. By late August, the prairie grasses along the railroad tracks (which we frequented on our safaris for butterflies, grasshoppers, and garter snakes) took on the fragrance of chamomile tea.

These are but random samples of my recollections of growing up in River Grove. As you delve into this book, it will undoubtedly bring back your own personalized moments as you travel down memory lane. I wish you a heartwarming journey.

Thank you, River Grove—not just from me, but from all of us that hold fond memories of you.

And thank you, Kenneth Knack, for preserving our memories—not just for us, but for future generations.

—Mario L. Novelli

ACKNOWLEDGMENTS

This undertaking would have been even more challenging had it not been for people like Frank Vesper, Don Gedeon, Rodger Hammill, Larry Casserly, Andy Madsen, and others who have taken the time to preserve images, stories, and names for future generations. I began my research by perusing Martha Ridge Vercammen's centennial publication *The Making of River Grove* and *When River Grove was Young* by Sylvia Norten Schacht. I also received assistance and guidance from such longtime residents as Mike Prokop; Brent Leder and his mother, Dorothea Leder; Jeanne Walsh; and Loretta Page. The endeavor was made much easier with the support of River Grove's president David Guerin and his administration and the River Grove Historical Commission (Mike Prokop, Nancy Hansen, Charlene Baloun, Sharon Apida, Lorenzo Fiorentino, Brent Leder, Elizabeth Hammon, and Bob and Linda Hodges). I have called upon my friend Mario Novelli to pen the foreword to this book. Mario is passionate about his community, and I have relied upon his extensive knowledge to serve as our toastmaster.

I would like to thank the following individuals for contributing photographs: Harry Schneider, Harry Smith Jr., Jim Oppedisano, Larry Casserly, Lisa and Gloria Murawska, Mario Novelli, Marty Kelley, David Rumsey, and Tom Tarpey Jr. and his sister Shawn Tarpey Campbell.

Additionally, I would like to thank the following institutions and organizations for contributing photographs: the River Grove Fire Department (Chief Larry LaRiviere), Triton College (Dr. Robert Connor, Dr. Deborah Baness King, and President Moore), St. Cyprian Parish, Franklin Park Public Library (Karen Gurski, local history librarian), River Grove School District 85.5 (Dr. Jan Rashid), and the Schiller Park Historical Society (June Oulund).

Others who provided stories, resources, or encouragement include the Facebook groups River Grove Area Community Connection and the Thirsty Whale Days in River Grove, Illinois. I would also like to thank the staff at Arcadia Publishing—specifically my title manager, Caroline Anderson, and Tim Sumerel; Don Hansen; as well as my mother, Virginia Knack Marischler, for advice and suggestions.

Throughout the following pages, I try to capture the essence of a community over 130 years in the making. While it is impossible to list all of the businesses, people, and events that have shaped the village, I have done my best to include as many as I could. Any errors or omissions are most regrettable. Lastly, I must thank my wife, Diane, once again for her perpetual love and support throughout this endeavor. The images appearing in this volume appear courtesy of the River Grove Historical Commission (RGHC) and the Village Archives (VA) unless otherwise noted.

INTRODUCTION

River Grove is my third contribution to the Images of America series. In writing this book, I continue to work my way along the course of the Des Plaines River—a journey that I actually took many years ago in a small inflatable raft beginning in the woods west of Evans Field to Greenburg Road and Des Plaines Avenue in Forest Park. It was a trip inspired by a story told by a childhood friend of Ernest Hemingway's who spoke to my English class at Proviso East High School and had rafted the Des Plaines along with the famous author. That story was the spark that flamed my interest in the river and spurred my imagination to think of those who have lived along its peaceful tree-lined banks.

Since I have resided my entire life less than two miles from the Des Plaines, each town that borders the river has had an impact on my life. When I was a child, my father once brought home a snapping turtle by mistake and my brother Eric and I escorted him as we released the creature into the river. I have had a fondness for its calming waters ever since.

River Grove is the home of Triton College. It was there that I met and wooed my muse Diane Leone. She said "yes" to my marriage proposal at the Hala Kahiki, where we first met for drinks after a class. I have enjoyed many a Gene & Jude's hot dog—perhaps even after catching a Pink Floyd laser show or after seeing a band at the Thirsty Whale. I get my hair cut at Mario Novelli's barbershop and Athletico has gotten me back in shape after a surgery or two. I have plenty of knowledge about the River Grove of the past 30 years, but I did not know much about its long history.

In 2018, the State of Illinois celebrates its bicentennial and River Grove, Leyden township's first organized village, will be celebrating its 130th anniversary. River Grove was incorporated October 6, 1888, but the settlement of the town occurred much earlier.

The Nevada-shaped community of River Grove was never adorned with grand Victorian-era homes; it was the farmhouse that dominated the landscape. River Grove still has many 19th-century homes—unlike its younger neighbor to the east, Elmwood Park. River Grove had farmland until the 1960s, when the last parcel was sold to build Triton College.

One has merely to step on the trails along the river to time travel back to the days before the airplane, automobile, or train transported people to and fro. The river, which was sometimes unnavigable due to low water, was nonetheless an important feature of the land. The Indians would say that they walked over the bones of their ancestors.

Through the following words and photographs, I try to share some of this town's colorful past. I hope that you will find this book informative and entertaining. It is truly an honor to be your tour guide.

One

THE ROAD TO CAZENOVIA

In 1818, the State of Illinois was created from the Territory of Illinois, sometimes referred to as the Old Northwest. The land now known as River Grove has been home to several tribes of Native Americans, of those, the Potawatomi were the last inhabitants before those of European ancestry arrived.

The Fort Dearborn massacre of 1812 had some perpetual effects on this area. The US government, in 1816 via the Treaty of St. Louis, created a 20-mile-wide diagonal swath of land to provide safe travel from Lake Michigan at the Chicago River to the Illinois River (see page 11). It was along this line in 1829 that the government granted Claude LaFramboise and Alexander Robinson, the Métis chief of the Potawatomi, large reservations on the northern border of this Indian boundary line at the Rivière aux Pleins (Des Plaines River). Robinson received his land in part for his assistance in signing the treaties, which surrendered the Potawatomi land, and for his role in saving the Kinzie family and Capt. Nathan Heald and his wife after the massacre.

The road to Cazenovia sounds like an old Bing Crosby and Bob Hope movie, but what about Whiskey Point Road, Spencer Road, and Bridge Street? All are names by which Grand Avenue was once known. Originally an old Indian trail, it was probably the route that Jesse Walker, the "Pioneer Preacher," and David Everett took after purchasing land here in 1833. Everett settled in a log structure that was formerly an old Frenchman's trading post or squatter's cabin, becoming the area's first white settler. In 1834, Walker and Everett built the first bridge over the river.

Brothers Alexander and Samuel Spencer bought land here on February 13, 1841, and built a hotel on the east side of the river that served as the post office. The brothers were from New York and are credited for having named the area Cazenovia. In 1850, the township was organized as Monroe but was quickly renamed Leyden. The Chicago & Pacific Railroad was extended to Cazenovia in 1872, adjacent to Whiskey Point Road. That same year, Sayles and Walker purchased 300 acres at a cost of $240 per acre, which is about $1.5 million in 2017. On April 13, 1873, the area known as Cazenovia was renamed River Park due to another Cazenovia already existing in the state.

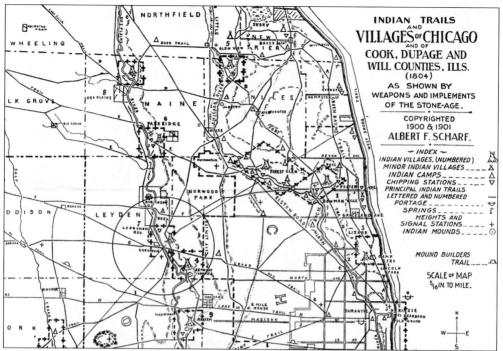

This map drawn by Albert F. Scharf shows how extensive the Native American presence was in this region around 1804. The area that is circled is now River Grove. Note how Indian villages straddled both sides of the river, including the mounds and chipping station near Evans Field. The Grand Avenue trail was a major transportation route, as it continues to be today. (Author's collection.)

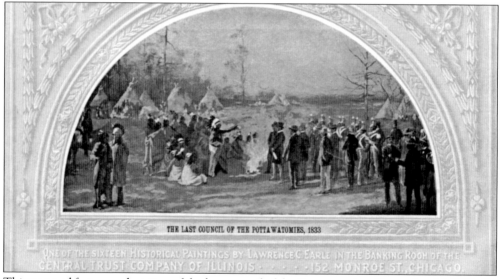

This postcard features a depiction of the last council of the Potawatomi on September 26, 1833. On that date, the native people ceded all of its lands east of the Mississippi River, with the exception of a few reservations, including those belonging to Claude LaFramboise and Alexander Robinson. Upwards of 5,000 Indians made their way to a temporary village by the Chicago River. After this event, land was made available for purchase by individuals. (Author's collection.)

The handwritten Treaty with the Chippewas, Etc., is dated July 29, 1829. Article IV grants Claude LaFramboise "one section of land on the Rivière aux Pleins, adjoining the line of the purchase of 1816" and two sections to Chief Alexander Robinson (Che-Che-Pin-Qua). Robinson was granted $300 a year for life and land "above and adjoining the tract herein granted to Claude LaFramboise." Robinson was reported to be 104–110 when he died in May 1872, but the 1860 census recorded him at age 72, which would have made him about 84. (National Archives.)

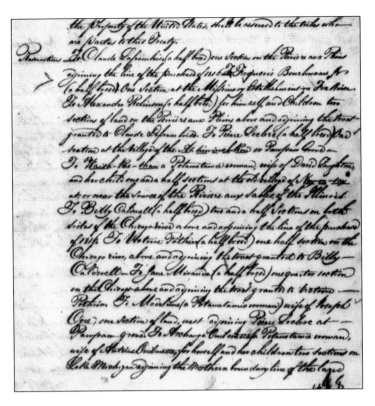

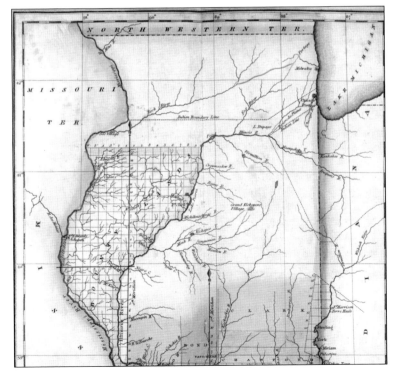

This map of Illinois was published in 1822. The map shows the 20-mile-wide Indian-free area from Lake Michigan to the Illinois River. River Grove is located along the northern Indian boundary line at the Des Plaines River. Note the spelling "Melwakee" (Milwaukee). (David Rumsey Map Collection.)

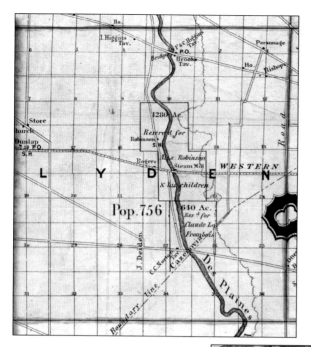

This 1851 Mayer & Co. Map of the Counties of Cook and DuPage by James H. Rees shows the 1,920 acres awarded to Alexander Robinson and Claude LaFramboise. At this time, the little settlement named *Cazenovia* is shown. Legend says the name came from the Spencer brothers Alexander and Samuel, who were originally from New York. Note the spelling *Lyden* (Leyden) and the population. (Library of Congress.)

This 1861 S.H. Burhans & J. Van Vechten map of Cook County, Illinois, shows Cazenovia north of the Indian boundary line, but other maps show it to the south. This area, site of some of the oldest homes in River Grove, was soon to take the name *River Park*. Note the names of the streets: River Road and Grand Avenue were Water Street and Bridge Street, respectively. (Library of Congress.)

The United States of America,

To all to whom these presents shall come, Greeting:

Whereas Jesse Walker and Edmund Weed, of Cook county, Illinois, have deposited in the General Land Office of the United States a certificate of the Register of the Land Office at Danville, whereby it appears that full payment has been made by the said Jesse Walker and Edmund Weed, according to the provisions of the act of Congress of the 24th of April, 1820, entitled "An act making further provision for the sale of the Public Lands," for the South West quarter of Section twenty six, in Township forty North, of Range twelve East, in the District of lands subject to sale at Danville, Illinois, containing one hundred and fifty seven acres and fourteen hundredths of an acre, according to the official plat of the survey of the said Lands returned to the General Land Office by the Surveyor General, which said tract has been purchased by the said Jesse Walker and Edmund Weed.

NOW KNOW YE, That the UNITED STATES OF AMERICA, in consideration of the premises and in conformity with the several acts of Congress in such case made and provided, have given and granted, and by these presents do give and grant, unto the said Jesse Walker and Edmund Weed and to their heirs the said tract above described: To have and to hold the same, together with all the rights, privileges, immunities and appurtenances of whatsoever nature, thereunto belonging, unto the said Jesse Walker and Edmund Weed and to their heirs and assigns forever, as tenants in common, and not as joint tenants.

In testimony whereof, I, Martin Van Buren PRESIDENT OF THE UNITED STATES OF AMERICA, have caused these Letters to be made patent, and the Seal of the General Land Office to be hereunto affixed.

Given under my hand, at the City of Washington, the sixteenth day of March in the year of our Lord one thousand eight hundred and thirty seven and of the Independence of the United States the sixty first.

By the President: Martin Van Buren
By A. Van Buren, Sec'y

Hudson McFarland, Recorder of the General Land Office.

The Reverend Jesse Walker, aka "the Pioneer Preacher," first purchased land on January 14, 1833, from Claude LaFramboise. Walker bought over 134 acres at $1.25 an acre. There were so many land patents being written that they were issued much later than the actual sales. This patent issued March 16, 1837, to Jesse Walker and Edmund Weed was signed by Pres. Martin Van Buren's son Abraham, who served as his secretary. (Author's collection.)

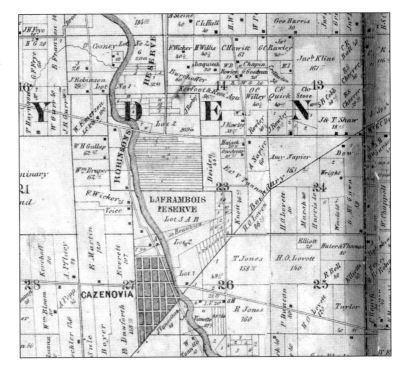

This map from 1862 illustrates how the Indian boundary line created some unique parcels of land and headaches for surveyors and land agents. Also seen are several parcels owned by the Vannettas, or Vanette, families. The parcels are in the vicinity of the home of Frank Vesper, claimed to be the oldest in Leyden Township (see page 15). (Library of Congress.)

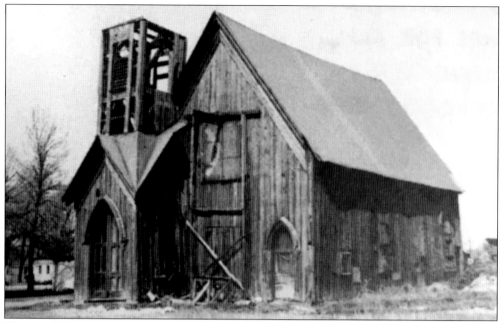

The once beautiful First Presbyterian Church of River Park, built in 1875, had become a barn on the Kabbe farm on Fullerton Avenue near Rhodes Avenue by 1950. Attendance began to wane beginning around 1900, and the church was closed about 1940. It had been moved to the farm and it was torn down at a later date. The photograph is from 1953. (VA.)

Publisher R.S. Rhodes was the inventor of the audiophone. Rhodes, who was partially deaf, discovered that if a person held a thin sheet of plastic in his or her teeth that poor hearing would improve. His device won a medal at the World's Columbian Exhibition in 1893. In 1902, Rhodes, age 60, was killed by a train. The train was stopped, and he was taken to his farm nearby. It is likely his hearing impairment played a role in his death. (VA.)

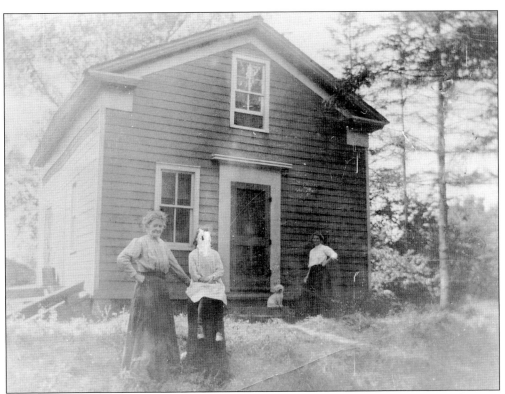

Local historians Frank and Evelyn Vesper identified the home located at 2620 North River Road as being the oldest in Leyden Township. The house was reputed to have been built in 1826 and owned by the Van Atta family, who are considered some of the earliest residents of Leyden Township. Current tax data lists the home as being built in 1893, but all the county tax records prior to 1871 burned in the Chicago fire. The little girl on the stump must have upset the owner of the photograph and her face has been lost to history. The photograph dates to the 1890s and features a Mrs. Bell and her daughters. To this day, the property is still surrounded by white pines, and the home is barely visible from the road. (Both, RGHC.)

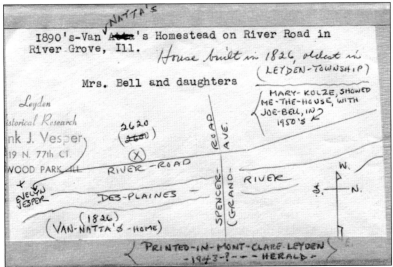

Gustave "Gus" Senf was born in 1839. The Senf family started a grocery store in 1845 near Grand Avenue and River Terrace. Then, in 1874, he built Senf's Hall on the corner of Grand and Thatcher Avenues. The 1880 census lists his occupation as a shoemaker. Senf also served as a volunteer fireman. (RGHC.)

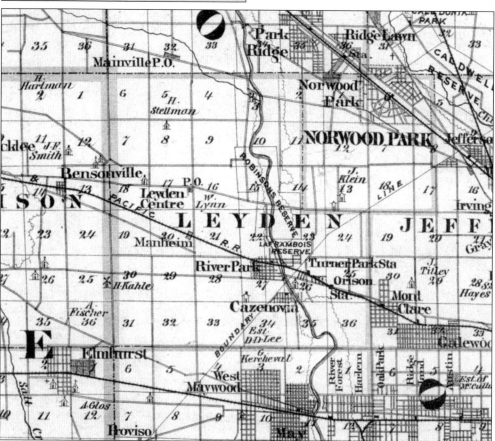

This map from 1876 shows the Chicago & Pacific Railroad, which had only laid tracks four years earlier. It is interesting to note that the name *Cazenovia* still appears on the map even though the area was by then known as River Park. It seems the name *Cazenovia* was applied to the Rhodes subdivision. Also, note that at this time Elmwood Park was known as Orison, and Franklin Park did not yet exist. (David Rumsey Map Collection.)

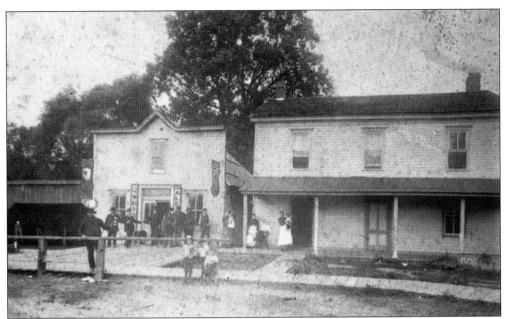

The Spencer brothers built a hotel (on the right) when the area was known as Cazenovia. It fronted Whiskey Point Road (Grand Avenue) close to the river. The photograph taken in the 1800s is purported to show Philip Schaeffer of Belmont Heights. The Schaeffers owned a farm on Belmont Avenue that was severely damaged in the tornado of 1920. For a time, Grand Avenue was also known as Spencer Road. (RGHC.)

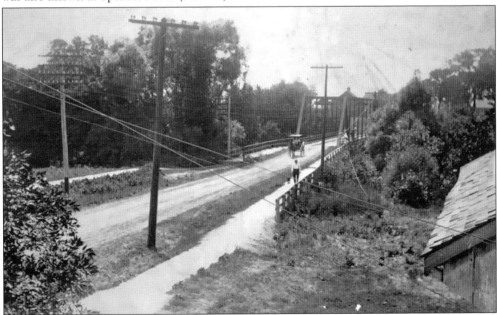

When this photograph was taken, Grand Avenue was a one-lane dirt road barely wide enough for a single horse and buggy. This may be difficult to imagine, since today the road consists of four lanes plus a turn lane. The vantage point of this photograph appears to be from the Spencer Brother's Hotel looking west along Whiskey Point Road or the aforementioned Spencer Road. The area is part of the forest preserves today. (RGHC.)

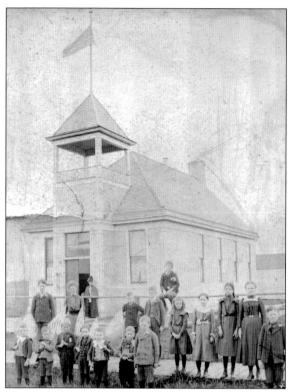

The original Rhodes School, seen here about 1905, was built in 1874 at Rhodes and Wrightwood Avenues. At this time, the current site on Fullerton Avenue was still farmland. Even though the school serviced part of Melrose Park along with River Grove, the student body was quite small in the early years. Note the wooden sidewalks and the patriotism displayed by some of the students. (RGHC.)

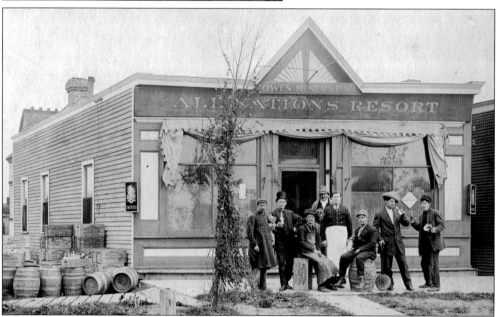

River Grove resident Owen McNerney operated the All Nations Resort in neighboring Franklin Park on Franklin Avenue. Owen was the fifth president of River Grove and served two terms from 1903 to 1907. The photograph displays a rather interesting cast of characters. Among the clientele is a man holding both a bottle and a banjo, another is sporting a pistol, and one rough-looking fellow is holding a teddy bear. (RGHC.)

Two

A River Runs through It

As River Park grew on the west, in 1874 another community called Turner Park grew on the east side of the Des Plaines River. Turner Park was run by the Chicago Turners Association, which lent its name to the rail station. The association built a large hall, and a general store was opened. It was the intention of the association to make the area a pleasure resort. In addition, growth continued on the west side of the river as the first Rhodes School was constructed as a small four-room wooden schoolhouse. In June 20, 1875, the First Presbyterian Church Society of River Park (see page 14) dedicated the new frame building in the Gothic style, with a seating capacity of 250, which was still not large enough to contain the crowd at its opening.

The population around 1880 was 200, and 80 percent of those were of German descent. In 1886, the Aux Plaines Camp and Rifle association purchased 169 acres for use as a rifle range and militia training ground, most likely in the St. Joseph's Cemetery area. A few prominent citizens, including Gus Senf and Paul Lau, conceived of the idea of incorporating Turner Park and River Park into a single community named River Grove. A vote was taken on October 6, 1888, at Senf's Hall and by the narrow margin of 23–19, River Grove was born. When River Grove incorporated, it became the first village to do so in Leyden Township. Neighboring Franklin Park was not incorporated until 1892.

In 1895, the all-volunteer River Grove Fire Department was formed. In 1898, the Elmwood Cemetery Company purchased a large tract of land from James P. Sherlock and his wife, Sarah Belle, for $105,000. The cemetery, at 400 acres, was allegedly the largest in the Chicago area. Bethlehem Lutheran Church was organized and founded in 1898. In 1901, St. Joseph's Cemetery was founded. Strangely, the name *Glendon Park* was used in the area although the actual boundary lines are unknown. The train station carried the name *Glendon Park* until 1907, when it was changed to *River Grove*. Through it all, Grand Avenue has always been the town's main street and the tie that binds east to west.

River Grove had a population of just 3,301 until 1940; in 20 years, it would grow by more than two and a half times, reaching 8,464 by 1960.

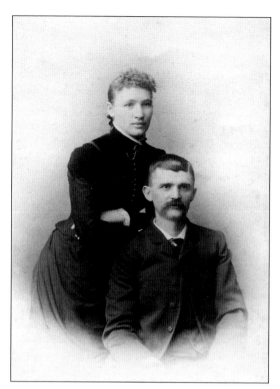

Paul Lau is shown here with his wife, Sophia. Paul was originally from Forest Park (Harlem, at the time) and is credited, along with James Bell and Gustav Senf, with conceiving of the idea of organizing a village. Paul was elected the first president of River Grove. He died in 1896 at the age of 38. His widow, Sophia, was the sister of Henry Buckman. (VA.)

This is a handwritten copy of ordinance No. 3 passed by the recently incorporated Village of River Grove to create a village seal. The ordinance was passed on October 17, 1888, just 11 days after the vote to incorporate barely passed by the slim margin of 23–19 at Senf's Hall. (VA.)

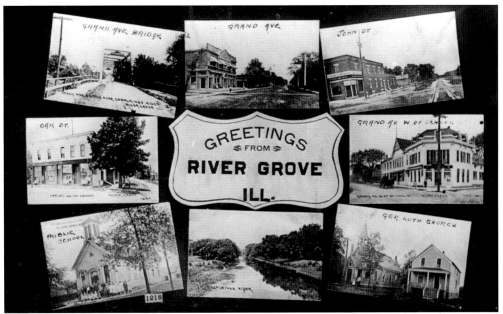

This multiview postcard is made up of eight individual postcards. A card like this made it easy for someone to show his or her civic pride. This one gives a complete glimpse of village life, featuring the river and the River Bridge along with the public school, its church, and several prominent businesses. (RGHC.)

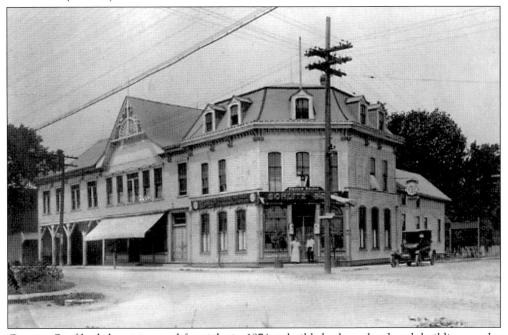

Gustave Senf had the vision and foresight in 1874 to build the large landmark building on the corner of Whiskey Point Road and School Street (later Thatcher Avenue), arguably the busiest intersection in the village. The large structure housed restaurants, saloons, doctors' and dentists' offices, dry goods, and currency exchanges. There was a large auditorium where dances and meetings were held. It was also the birthplace of River Grove. (RGHC.)

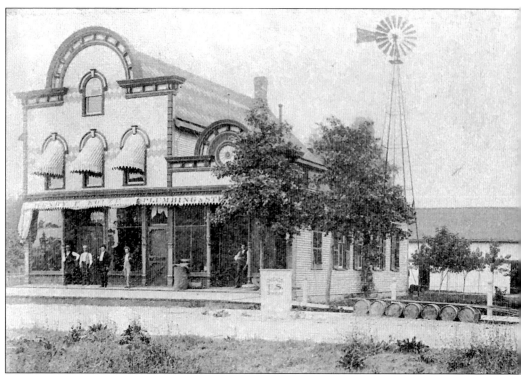

The Kolze family was one of the earliest and most influential families in Leyden Township. In fact, the village of Schiller Park was originally named Kolze, and Henry James Kolze owned a large two-story roadside inn, restaurant, tavern, and picnic grove at Irving Park Road and Narragansett Avenue in the 1890s. Henry F. "Heinie" Kolze was elected president of River Grove in 1911 and is

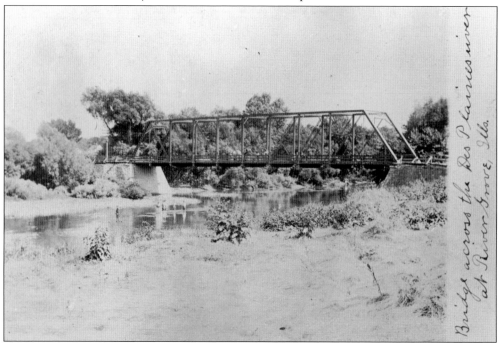

Bridge across the Des Plaines river at River Grove, Illa.

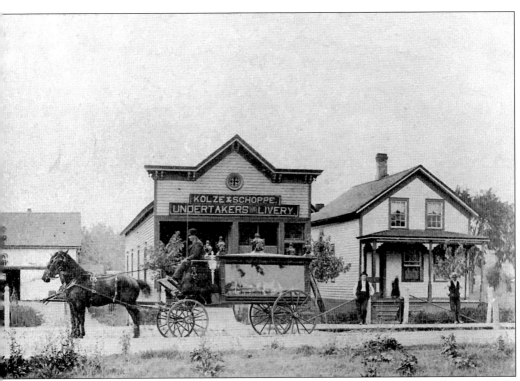

seen on his horse-drawn hearse. Heinie owned the plumbing store on the left and nearly all the land on the north side of Grand Avenue from Struckman Avenue to Auxplaines Street. Kolze's undertaking partner, Berny Schoppe of Bensenville, supplied the horses. (RGHC.)

At right, Charlie Eltman (left) and Frank Bees appear to be casually enjoying a nice day whiling away the hours on the old River Bridge in this photograph taken in 1899. The 1900 census lists Charlie as a 38-year-old widower farmer living in River Grove with two sons, a daughter, his sister, and his mother. The Eltmans were one of the earlier families in the community. (RGHC.)

On the opposite page, an early view of the River Bridge shows several people wading in the water. The area on the northeast bank was known as "the beach" and was a popular swimming area before the river became polluted. This bridge replaced the old Walker Bridge in 1882 and had a sign affixed at the top of both sides that warned there was a "$10 fine for driving over the bridge faster than a walk." (Franklin Park Library.)

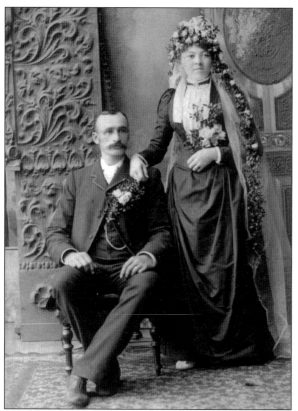

Seen on their wedding day, September 17, 1890, Henry Buckman and Bertha Senf were owners of the "historic house." Henry served as village clerk, and Bertha was the daughter of local businessman Gustave Senf. Henry is likely seated in the photograph so that the height difference between husband and wife would not be as dramatic. Bertha is probably wearing a black dress because it was her best dress. Typically, only women from the wealthiest families wore white dresses. (RGHC.)

This unidentified family apparently lived on Grand Avenue. That assumption is highly likely since Grand Avenue was one of the few streets to have wooden sidewalks. The picture can be dated to sometime prior to 1907. It was in that year that all wooden sidewalks were condemned by unanimous vote of the village officials. (RGHC.)

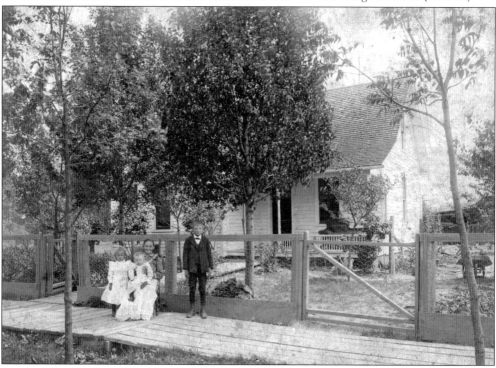

This postcard can be dated to sometime between 1910 and 1924. The Gottfreid Brewing Company was a local brewery that sold as many as 50,000 barrels in a single year. The tavern had a picnic area adjacent to the property. Turner Park Grove was located behind the tavern south of Grand Avenue. It may have been the "grove" immortalized in the name *River Grove*. (Mario Novelli.)

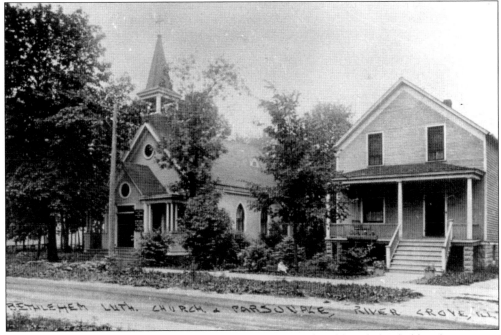

On May 8, 1898, Bethlehem Lutheran Church was organized and founded. It held its first services in the Turner Park School. The church located on Oak Street was dedicated in October 1899 and is seen alongside the parsonage. Several elements of the original church were later incorporated into a new church building and the old church was converted into a school. (Franklin Park Library.)

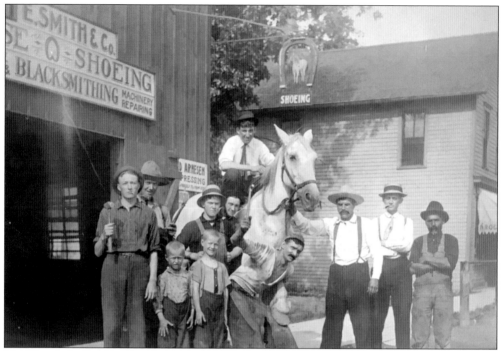

The Smith & Co. blacksmith shop was located on the north side of Grand Avenue west of Struckman Avenue in 1890. The blacksmith was one of the first and most important businesses to set up shop in a community when nearly everyone owned a horse. The building on the right would later on be home to the Village Dairy at 8600 Grand Avenue. (RGHC.)

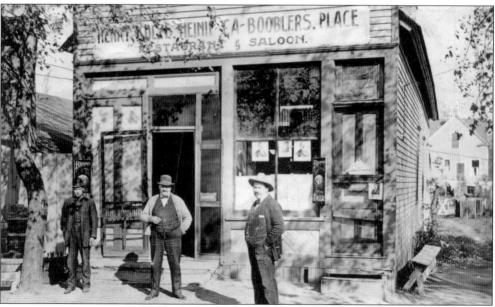

Henry Kolze (center) converted his funeral parlor into a restaurant and saloon. He was an earlier purveyor of Budweiser, indicated by the small sign near the door. Budweiser (called "the King of Beers") was first brewed in 1876 in St Louis. This structure was presumably lost in a huge fire on Kolze's Grand Avenue property on March 30, 1910. (RGHC.)

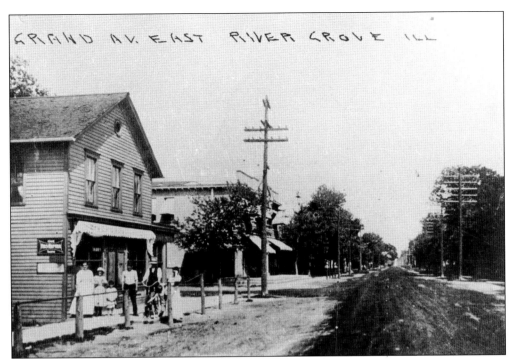

GRAND AV. EAST RIVER GROVE ILL

In this postcard, the building seen on the left would later house the Village Dairy and the Kolze building (right) at Grand and Struckman Avenues. A few years earlier, the gentleman on the bicycle would have had to dodge the "road apples" left behind as farmers would sometimes march cattle down Grand Avenue clear to Whiskey Point at Grand and Armitage Avenues on the way to the stockyards. (RGHC.)

This c. 1890 photograph shows Mayor Charles Neitzke and 13 volunteer firemen demonstrating their daring and skill. Among those present are Bill Boldt, Jim Bell, Otto Koch, Ben Buckman, Dick Buckman, Charley Daniels, Herman Giertz, Frank Fara, Oscar Streetz, Gus Senf, Chas Frick, Charles Giertz, and horses Queenie and Barney. (Larry Casserly.)

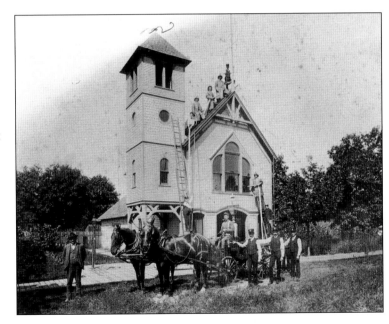

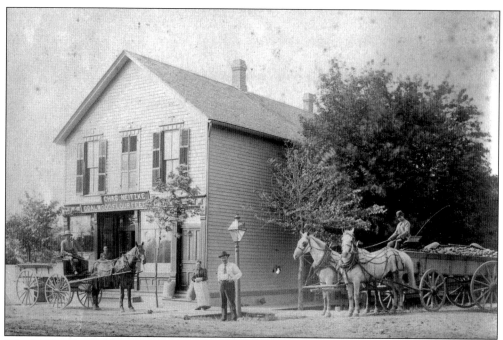

Charles Neitzke and his wife, Nellie, (not specifically identified but possibly in the center by the streetlight), ran this coal, wood, flour, and feed store in River Grove. Charles, the former mayor, was appointed jailer at the Cook County Jail in 1907. Nellie died in October 1924, and Charles joined her in July 1926. They both lie in eternal repose in Elmwood Cemetery. (RGHC.)

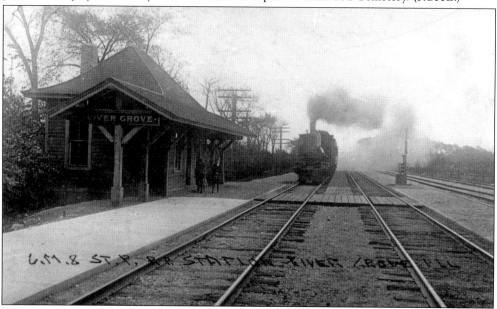

The original Milwaukee & St. Paul train station, shown here around 1920, was north of the tracks on the east side of Thatcher Avenue. The station carried several names, including Turner Park, Glendon Park, and finally, River Grove. The first trains began running along these tracks in 1872. To the right of the train is the pouch catcher crane. Pouches full of mail would be snatched by passing trains without stopping. (Franklin Park Library.)

John Pfeiffer served as a lamplighter in River Grove. When streetlights were first installed, the lights would need to be lit each evening, usually by a wick on a long pole. In the morning, the lighter would return to put them out using a snuffer on the same pole. Early streetlights generally burned oil, or other combustible liquids, with wicks. (Mario Novelli.)

The Eltman house still stands at 2819 Struckman Avenue and is typical of the utilitarian style of River Grove homes built during the late 19th century. In this photograph from 1891 taken just three years after the home was built are, from left to right, "Father," Marie, Sophie, and "Mother." Mrs. Eltman was the daughter of John Pfeiffer, and he lived at this home as well. (RGHC.)

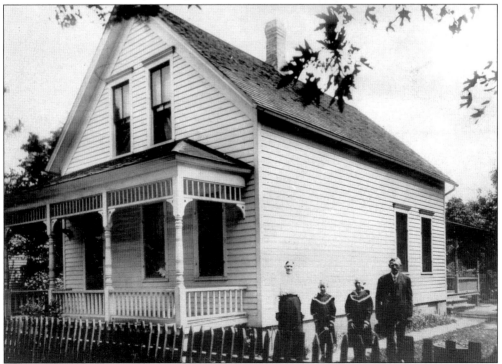

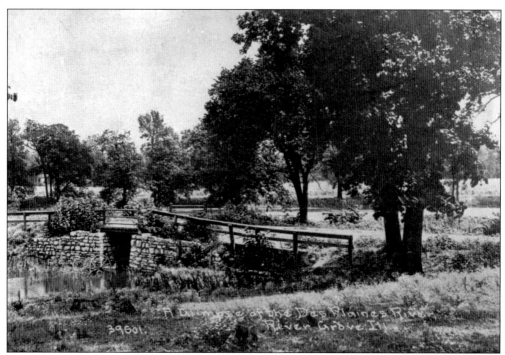

This "glimpse of the Des Plaines River" shows a footbridge built from a plan presented to the village in 1890 by R.S. Rhodes. Located at Herrick Street, the view is facing southeast. Nothing remains of the bridge today, as the forest preserve has reclaimed the area, which had once been partially cleared by the woodsman's axe for timber or to create pastures. (Franklin Park Library.)

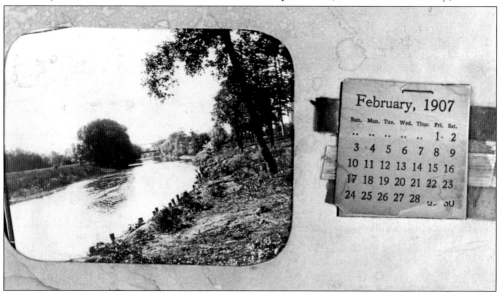

This image, with a view looking north, shows the River Bridge off in the distance. Interestingly, all the clearing along the river was apparently done prior to February 1909. This coincides with the view of the footbridge seen in the previous image. The Forest Preserve District of Cook County was formed in 1914, created the groves later known as Fullerton Woods, Jerome Huppert Woods, and Evans Field, and has allowed the forest to reclaim the land. (Franklin Park Library.)

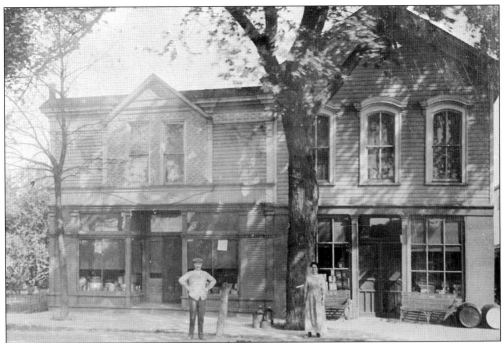

Charles O. Streetz and his sister Olga, the village's postmaster and postmistress, pose in front of their father's store in the early 1900s. The building on the left, which stood on the north side of Grand Avenue just west of Thatcher Avenue, was built in 1850. It served as the village post office beginning in 1893. The elm tree behind Olga was said to have been planted during the ground breaking for the buildings. (Franklin Park Library.)

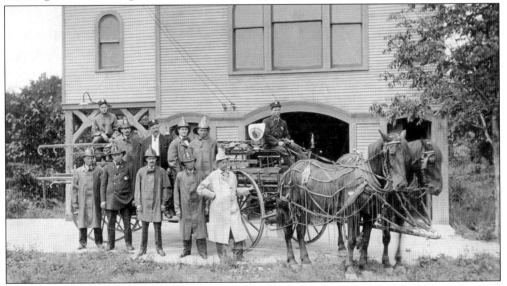

As the town grew, better firefighting equipment was needed. Although the equipment is still horse drawn, the fire department is seen with a hook and ladder. Pictured are, from left to right, (first row) Henry Giertz, Leo Dahlman, Oscar Streetz, John Boldt, Chief Hallie Lane, and horses Queenie and Barney; (second row) Tony Echardt, William Boldt, Jack Quinn, Otto Senf, unidentified, and Herman Giertz. (Larry Casserly.)

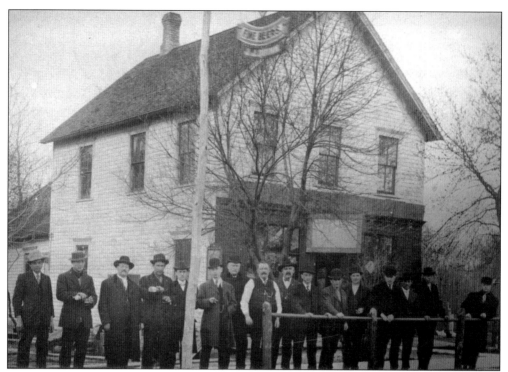

JJ Quinn's Place was located at approximately 8670 Grand Avenue, west of the current American Legion Hall. Note the hitching rail in front. Horseback riders who came out of the nearby forest preserves would tie their horses off and quench their thirsts. The building, which gained a somewhat sordid reputation, was torn down in the 1960s and replaced by apartment buildings. (RGHC.)

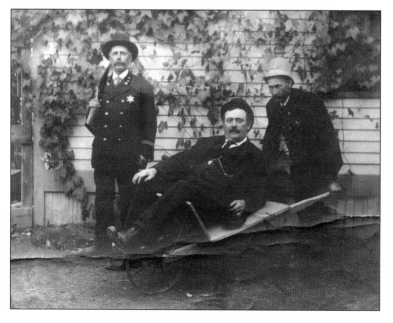

The fun-loving single-term mayor John J. Quinn chose an odd mode of transportation back in 1909 but seems quite relaxed as he catches a ride in a wheelbarrow. Police chief Frank Wiemerslage stands stoically, guarding the precious cargo as one of his patrol officers does the heavy lifting. (RGHC.)

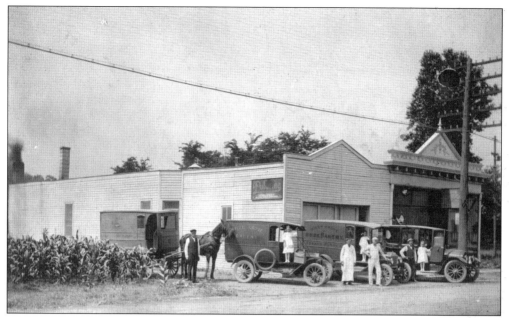

Edward Ploner's River Grove Bakery was located on the south side of Grand Avenue near Thatcher Avenue. The bakery was built in 1914. This photograph from 1916 shows Ploner's three daughters standing on the delivery trucks; from left to right are Elsie, Elvira, and Carolyn. Note the cornfield on the left side of the photograph. It was located just about where Mario Novelli's barbershop is today. (RGHC.)

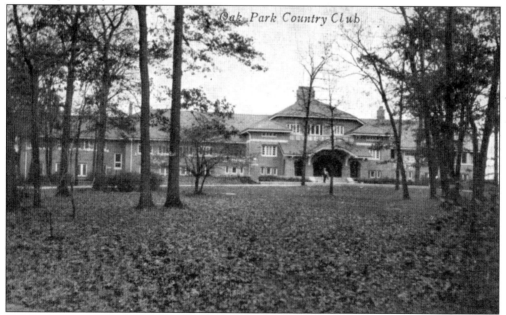

Oak Park Country Club, founded in 1914, straddles the boundary line with Elmwood Park. The 18-hole golf course designed by Donald Ross is its centerpiece, along with tennis courts, a pool, and a trap range. A portion of the property, originally 190 acres of unincorporated land, was sold off to build Elmwood Park High School. The late radio personality Paul Harvey was a member for 46 years. (Author's collection.)

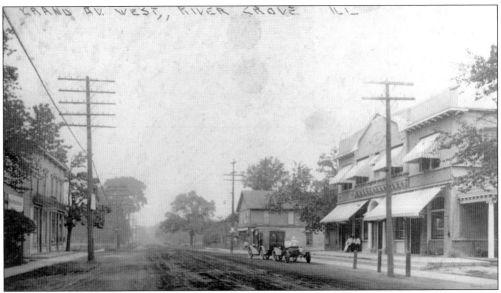

With a view looking west on Grand Avenue between Struckman Avenue and Auxplaines Street, this undated photograph was taken during a period of transition from horse and buggy to the internal combustion motor. Most of the hitching rails are gone. When combined with the following photograph, it provides an almost panoramic view of Grand Avenue around 1910. (Franklin Park Library.)

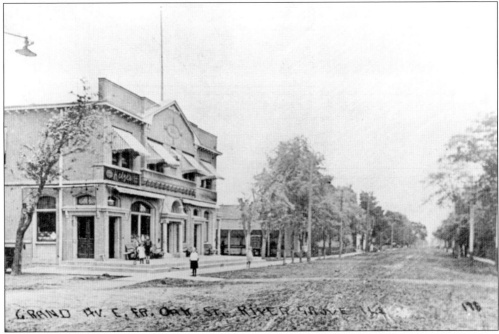

Henry Kolze built a new, sturdier building at 8554 West Grand Avenue in 1910 to replace the one lost in a fire (see page 22). Later known as the Playground, the vacant building burned in September 1932. The former mayor had been killed five years earlier when a Milwaukee Road train struck his car. The Grand Pointe Condominium was built on the site in 2005. (Franklin Park Library.)

Herman and Harriet "Hattie" Giertz are shown here on their wedding day. Herman was a teamster, locomotive fireman, and one of the original volunteer firemen in town. On December 11, 1924, Herman and Hattie were blessed with triplets, which was quite a rarity in those days. Albert Giertz, the last surviving triplet, died at age 90 on March 7, 2015. (RGHC.)

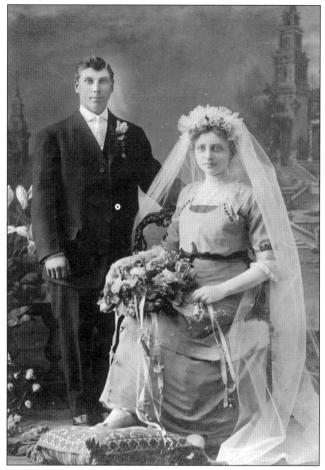

The Herman Giertz family lived in this home at 2409 Thatcher Avenue before moving to a farm near Bensenville. Their triplets received national notoriety during World War II when the brothers—Albert, Herbert, and Gilbert—served in the same antiaircraft outfit, earning the nickname "the Three Musketeers." The farmhouse, built in 1913, was sold in 2017, torn down, and replaced by a new structure. (RGHC.)

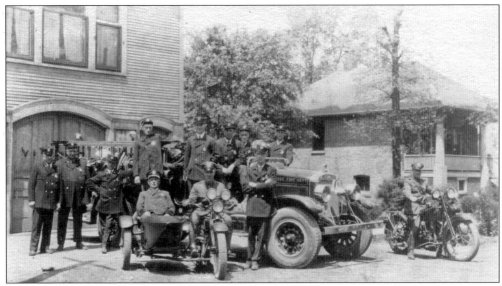

The fire and police departments pose outside of the village hall at 2812 Auxplaines Street in the 1920s. From left to right are (first row, seated) Chief Frank Wiemerslage, W.M. Stuckrath, Fred Peterson, and Jim Doherty; (second row) Ted Rasby, Leo Dahlman, Walter Mickey, William Bolt, Joe Bruxer, Tony Eckardt, William Kossack, and Whity Bruyt. It was said that Chief Wiemerslage rode a bicycle around town until the village bought the motorcycle with the sidecar. (RGHC.)

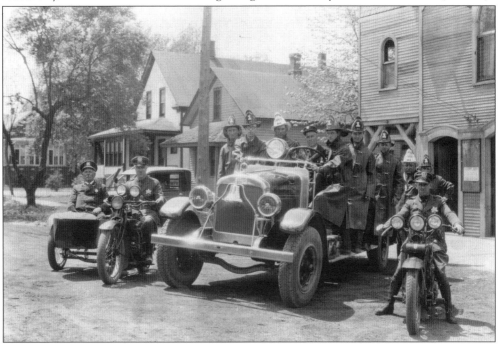

This is another look at the police and fire departments, this time with a view facing southwest along Auxplaines Street towards Center Street. The two homes seen in the background still stand. Note the macadam street. Unlike some suburbs that used cobblestone pavers, most roads in River Grove were crushed gravel until they were paved in either concrete or asphalt. A telephone pole still sits in approximately the same spot today. (RGHC.)

Located at 8600 Grand Avenue, the Royal Blue Store was part of an early chain of independent grocers. The proprietor was George Marx, who also owned a gas station next door. Royal Blue would eventually become part of Consolidated Foods, which would build a large distribution center on the south end of the village in the 1950s. (RGHC.)

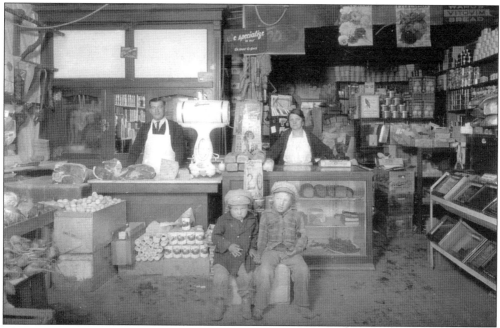

The Stein family's first store on Grand Avenue was a general store where one could purchase canned goods and other general merchandise. These little shops flourished in the days before supermarkets and national chains. In this photograph are Saul and Margaret (Blanchard) Stein along with sons Les (left) and Frank. Another son born later, Glenn, went on to become a teacher at River Grove School. (RGHC.)

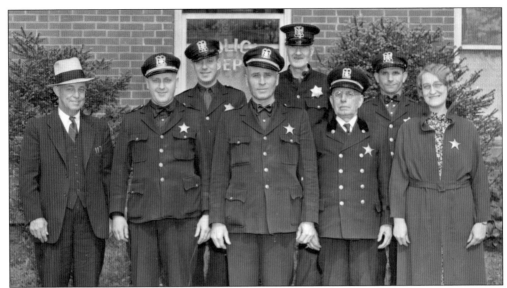

This c. 1940s photograph shows just how small the village's police force was at that time, considering the population was probably about 3,500. From left to right are (first row) Dan Gillion, Adolph Rickert, Al Eckhardt, Frank Wiemerslage (chief), and Mae Collins (first matron); (second row) Harry Burns(?), unidentified, and Frank LaPreste. A police matron was important in the days before female police officers; she would take care of children and female detainees. (RGHC.)

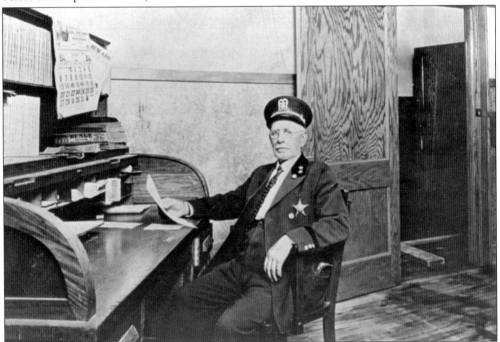

Longtime River Grove police chief Frank "Peanuts" Wiemerslage is seen seated at his rolltop desk. Legend states that at age eight, he fished with Chief Alexander Robinson on the Des Plaines River. In 1925, Wiemerslage arrested people for driving automobiles down sidewalks on Chestnut Street and River Road after complaints from people who had their lawns driven on. Drivers were doing so because of the poor conditions of the roads. (Franklin Park Library.)

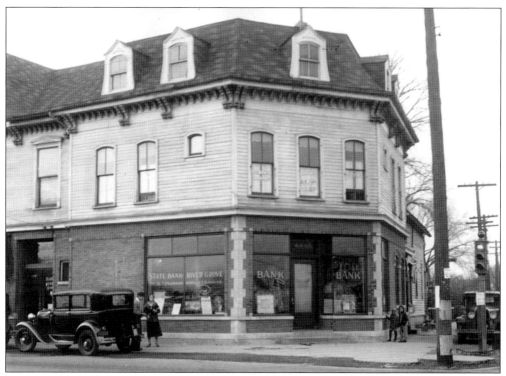

Taken at the time of the infamous bank robbery of August 9, 1930, this image of Senf's Hall looks like a scene right out of *Bonnie & Clyde*. The clever criminals set a diversionary fire at the National Monument Works, located about two and a half blocks away. The thieves got away with $3,000 but apparently dropped a few coins, which were picked up by a young Andy Madsen. (VA.)

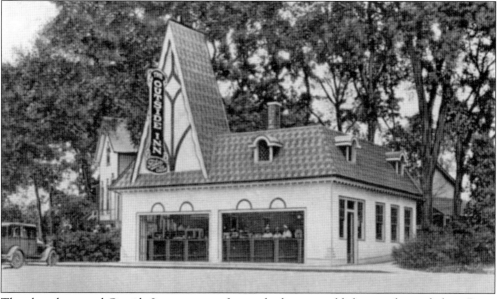

The cleverly named Outside Inn was one of many barbecue establishments located along River Road. The business, one and a half blocks north of Grand Avenue, began in 1916 and lasted until the late 1930s. The restaurant had both table and curbside service. (VA.)

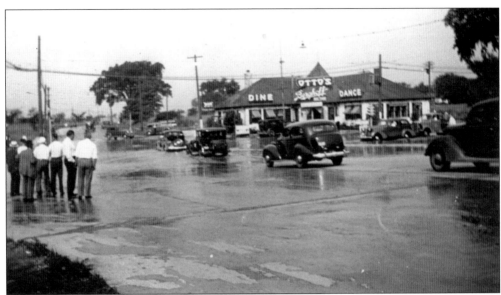

This photograph was taken from the east side of River Road and the view looks west toward Otto's during the flood of 1938. Patrons of the Thirsty Whale will recognize Otto's unique structure; it was the last business to call the building at 8800 West Grand Avenue home. The building was torn down in 1996, and now the site is home to a gas station and McDonald's. (Franklin Park Library.)

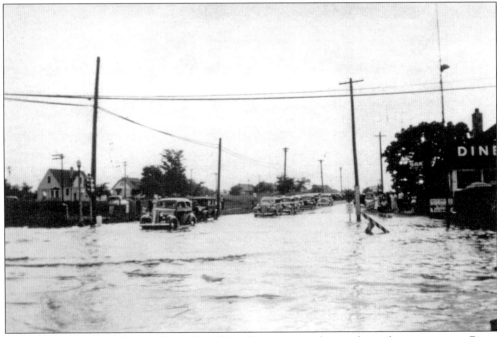

Cars are lined up heading eastbound on Grand Avenue ready to take a chance crossing River Road during the 1938 flood. The house at 2662 Clarke Street is clearly visible. Today, that view would be blocked by the Subway restaurant and a large apartment building. During the most recent flood in 2017, the village blocked the roads and created detours rather than allowing cars to attempt a crossing. (RGHC.)

In the 1930s, this Texaco station stood next to the Royal Blue store around 8600 West Grand Avenue. The visible pump on the right was called a "Mae West" due to its shapeliness. The gas would be pumped into the glass chamber so that the customer could see the fuel, then gravity would flow it into the vehicle. Today, those pumps are worth thousands to collectors. (RGHC.)

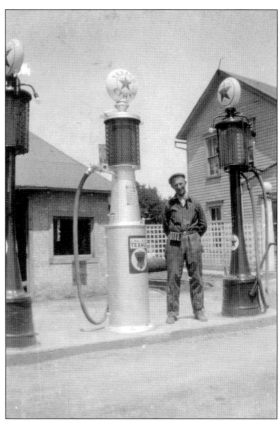

The spare tire cover of the vehicle in the foreground may include an admonition to "Drive safe," but apparently, not everyone heeded that warning. It appears that someone is standing on a fender or a running board of a car up the road. This photograph was taken at Grand Avenue and River Road, and the view is looking north during the flood of 1938. Today, the village would close the road in that condition. (RGHC.)

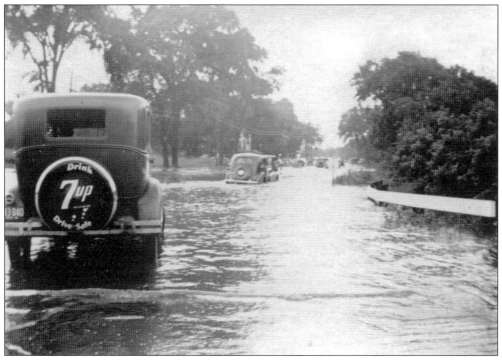

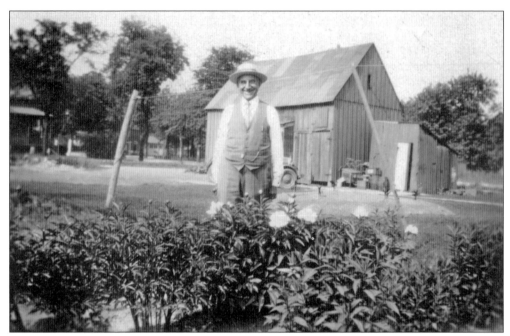

Rudolph Grohnke proudly stands behind a row of peonies and in front of a barn located behind the Royal Blue Store on Grand Avenue. Peonies were a popular flower among River Grovers. They can still be spotted in backyards and flowerbeds throughout the area. (RGHC.)

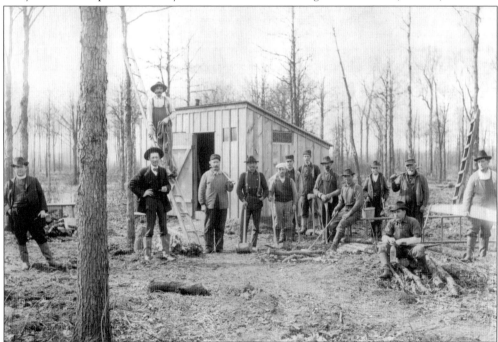

In 1901, the land was cleared for the second of River Grove's cemeteries, St. Joseph Cemetery. Much of the land was heavily wooded with native growth, and it took three years to clear. The combined interments of the two cemeteries of St Joseph's (180,000) and Elmwood (87,781) outnumber living residents (10,134) nearly 27 to 1. (RGHC.)

Three

Faith, Knowledge, and Tributes

Birth, education, and death make up a cycle of life. Where these events occur shapes people's lives. The settlers in this region were a mixed breed, but the majority were of Germanic origin. The German revolutions of 1848–1849 resulted in a large influx of German-speaking immigrants, many of whom were farmers or tradesmen, settled into the Chicago area. Lutheran church services began as early as 1886, but the first church in the area, the Bethlehem Lutheran Church, was not formed until 1898. It was the only church in the community for 20 years.

For immigrants coming to Chicago, education was an important key to advancing in life. The first school was known as the Turner Park School, which in turn became River Grove School. Thatcher Avenue was originally named School Street. The Rhodes School was built to serve those living on the west side of the river. River Grove does not have a public high school of its own within its borders, but two Catholic high schools were built, along with a community college that serves several municipalities.

At the end of life, the body is laid to rest. The quiet pastures and groves of trees found here ensured a peaceful repose. In 1896, the Elmwood Cemetery Company was formed. Two years later, it purchased 400 acres from James P. Sherlock for $105,000. This created the largest cemetery in the Chicago area. The cemetery had three entrances and extended as far east as Seventy-Sixth Avenue in neighboring Elmwood Park. Many years later, everything east of Eightieth Avenue was sold off and became the Westwood subdivision of Elmwood Park.

In 1901, St. Joseph's German Catholic Cemetery was created and listed in a directory as River Grove, "formerly Glendon Park." Most of the land on which the cemetery is situated was formerly part of the LaFramboise reservation. The first burial took place on October 22, 1904. Several prominent people are interred in the local cemeteries, including veterans of the Civil and Spanish-American Wars, former local politicians, and celebrities. The two cemeteries boosted the local economy with taverns, florists, and other businesses.

When Elmwood Cemetery opened, it was one of the few cemeteries in the area that had Greek burials. Unlike St. Joseph's Cemetery, Elmwood is nondenominational, and visitors will see monuments inscribed with the surnames of all nationalities and ethnicities.

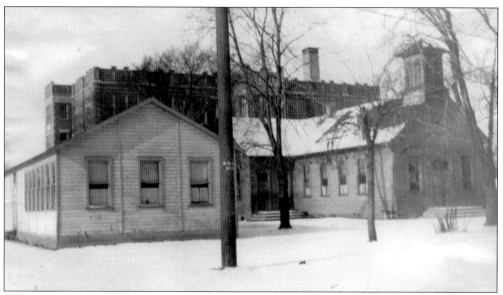

The River Grove School began as the Turner Park School in 1867. This photograph shows the early evolution of the school. On the right is the original structure; on the left is an early addition. The large edifice behind them both is the large brick school that replaced them. The 1928 structure has been surrounded by even more additions as enrollment had outpaced expectations. (RGHC.)

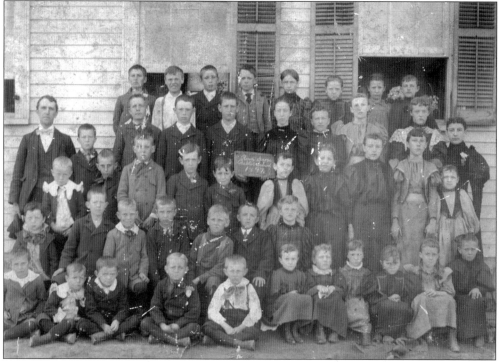

The students of the River Grove School were apparently encouraged to wear their Sunday best for the school picture in 1897. The two-room school housed children of all ages. While it was common not to smile in formal photographs, some actually appear to be frightened by the experience. (RGHC.)

The Bethlehem Lutheran Church was built at a cost of $1,990 in 1886. The first services were held exclusively in German until 1904, when an English service was added. The schoolhouse located in the back was constructed in 1901 and was used until 1951, when the church was converted into a school after the construction of the current church. (Author's collection.)

This photograph of a fire drill at St. Cyprian School provides a glimpse of the River Grove Baptist Church at 2560 Clinton Street. The church, built in 1925, was sold in the 1950s and became a residence. The building has since been replaced by newer residences. A new school was built on the empty frontage in the foreground. (Franklin Park Library.)

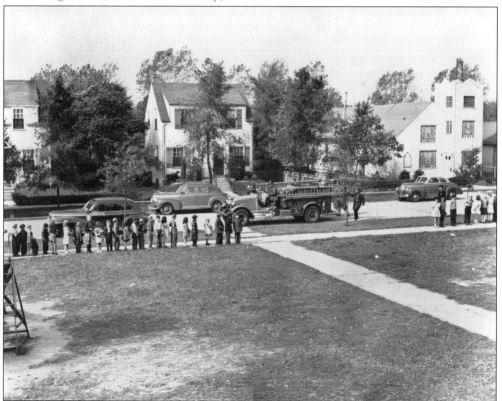

Grace United Church of Christ at 2600 Budd Street was built in 1927. The original congregation, the Evangelical Church of River Grove, initially met in the first village hall on Auxplaines Street. The church building for the recently renamed Grace Evangelical Church of River Grove was constructed at the same time as the new village hall, and the village gave the old village bell to the church for use in its belfry. (RGHC.)

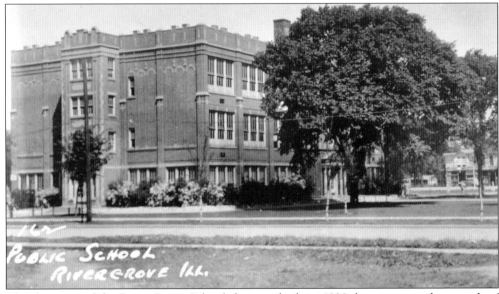

The sheer size of the River Grove School that was built in 1928 demonstrates the growth of the eastern side of the community at that time, while the Rhodes School was still a one-room schoolhouse servicing western River Grove. This structure would see several additions over the years. The main building is still in use but is virtually surrounded by later additions. The view is looking northwest from Thatcher and River Grove Avenues. (RGHC.)

The first St. Cyprian Church was a temporary structure. The exteriors of the "portable" churches were plain by Catholic Church standards, and a passerby would be hard pressed to identify the structure if it were not for the crucifix above the door. These portables were inexpensive and allowed the parishes to raise money for more permanent structures. The Colonial Revival–style school can be seen behind the church. That building would later influence the design of the permanent church. (St. Cyprian Parish.)

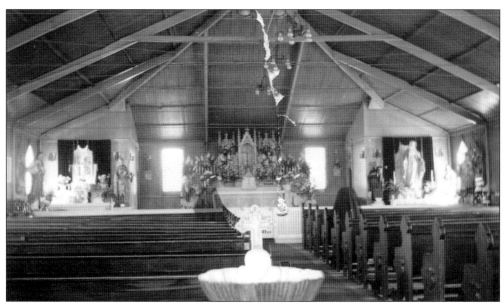

The spacious interior of St. Cyprian Parish Church is seen here. In the 1920s, the Archdiocese of Chicago set up several of these temporary churches. This one served the community from 1929 until 1950, when ground was broken for the current permanent church that stands there today. (St. Cyprian Parish.)

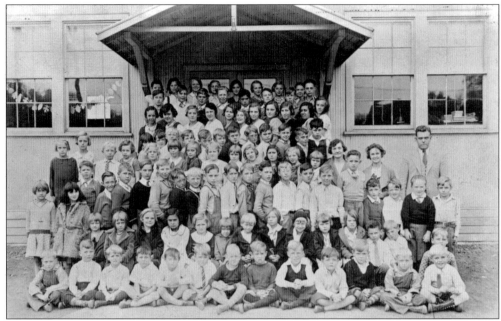

The Rhodes School class of 1933–1934 certainly had to squeeze together to all fit in the class photograph. The younger children were placed up front, and the older students are in the back. Judging by the large group, it is easy to see why a new school would be needed after the war. (Rhodes School.)

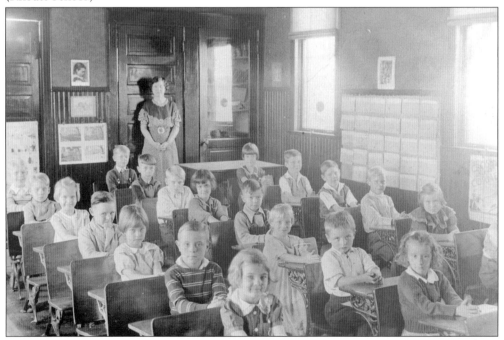

This image offers a rare look into the little one-room Rhodes School. The school accepted students from River Grove, as well as Melrose Park and Franklin Park. Depending on which side one's house fell on, the dividing line would dictate which school one attended. In one case, the line literally fell between bedrooms, and the sisters had to go to separate schools. (Rhodes School.)

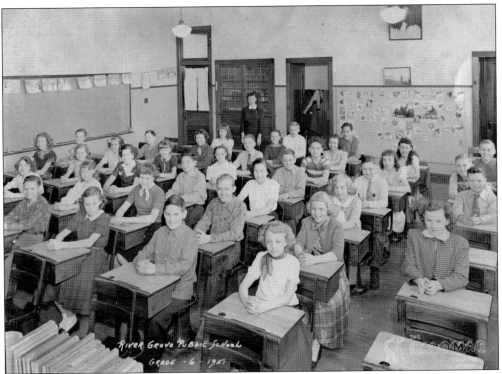

The large River Grove school pre–baby boom sixth-grade class of 1941 reflects a growing community. The population in 1940 was 3,301, or nearly seven times what the population was in 1920. Of the 36 students, there was almost an even mix between boys and girls. Note the inkwells on the desks. It was usually the job of one of the boys to keep them filled. (VA.)

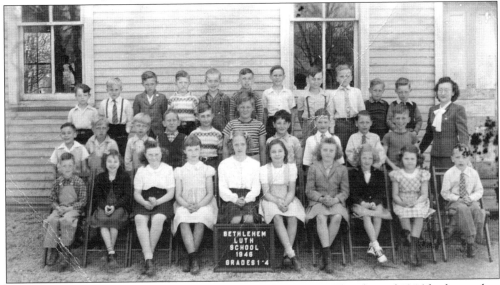

The Bethlehem Lutheran Church School was built in 1901. The class of 1946 had two class photographs. This one was for grades one through four, and a second one shows grades five through eight. The school had 63 pupils in all. The schoolteacher seen standing on the right is Luella Spitzacke. (VA.)

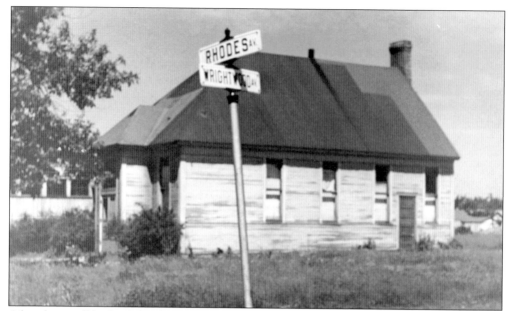

After the new Rhodes School was built on Fullerton Avenue, the old school, which had served the community from 1874 until 1946 at Rhodes and Wrightwood Avenues, fell into disrepair. The building was torn down, and the River Grove Bible Church was constructed on the site. Across the intersection from the old school in the 1970s was Aristodemo's grocery store at 2537 Rhodes Avenue. (Rhodes School.)

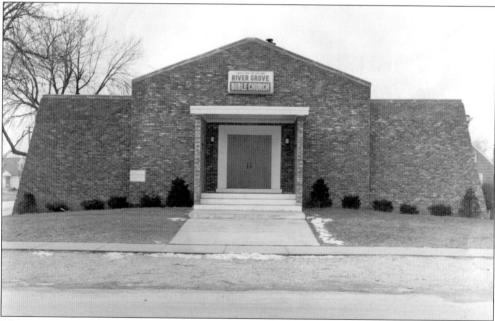

The River Grove Bible Church (shown before its steeple was added) was built in 1952 at 2250 Rhodes Avenue. The church was created in 1949, when the River Grove Baptist Church, which had been located on Clinton Street, decided to merge with the Rhodes Gospel Church. In 1974, the church signed a contract allowing the village to use the lot behind it as a village playground. (RGHC.)

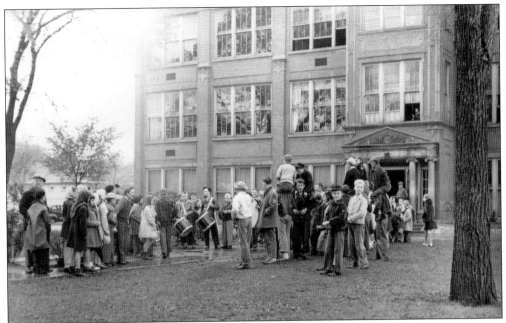

A sixfold increase in population from 484 in 1920 to 2,741 in 1930 necessitated the building of a new, larger River Grove School. Ground was broken on September 25, 1929, for the 11-room, 429-foot-long, 165-foot-wide, $93,000 modern brick building just about a month before the stock market crash triggered the start of the Great Depression. This entrance would eventually be closed off after further additions were made. (RGHC.)

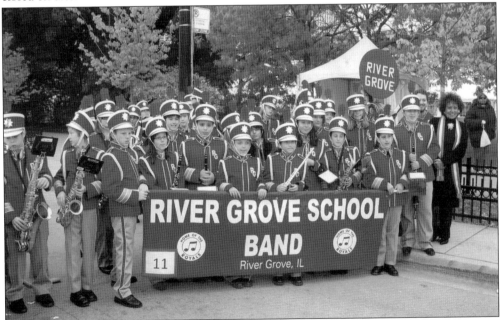

The River Grove School band has a long history of playing in parades and other functions since its very first public concert back on February 25, 1929, at Senf's Hall. In this undated photograph, the band prepares for a parade under the proudful gaze of then village president Marilyn May. (River Grove School District 85.5.)

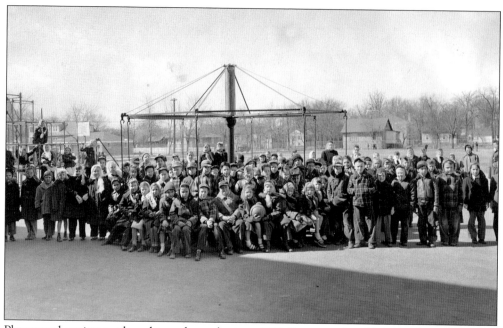

Playground equipment has changed greatly since 1951. Rusty steel and hard surfaces have been replaced by plastics equipment and mulch. Many former students still have fond memories of the thrill of playing on the monkey bars and merry-go-round and probably still have the scars they earned as children. (River Grove School District 85.5.)

The edifice that currently houses Bethlehem Lutheran Church at 2624 Oak Street was dedicated on November 4, 1951. The church was built to the south of the old church. The old church was converted into classrooms and used in that manner until 1961, when it was demolished in order to construct a new facility, which included a gymnasium, stage, and meeting rooms in addition to four classrooms. (RGHC.)

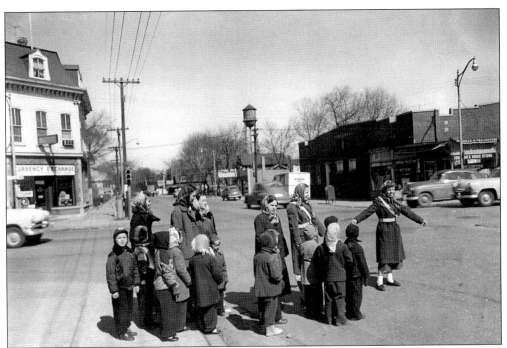

School crossing guards have always held an important role at River Grove School, especially at the intersection of Grand and Thatcher Avenues, one of the busiest in the village. In this photograph, a young Linda Green (Hodges), fourth child from left, wears a babushka along with her schoolmates who are also being helped across Thatcher Avenue by a crossing guard. (RGHC.)

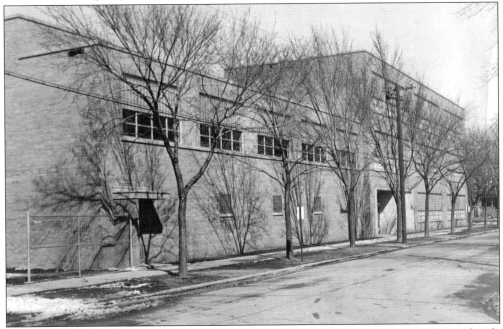

In 1953, this large addition to the River Grove School was built. It was added to the south side of the 1928 building along River Grove Avenue. The building was needed to accommodate the post–World War II baby boomers. (River Grove School District 85.5.)

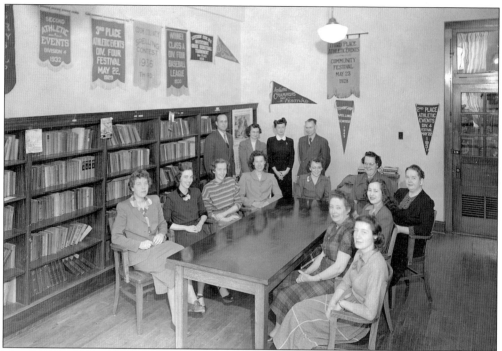

The faculty of the River Grove School poses in the school library around the early 1950s. The school library was the only library in town until the Friends of the Library was formed in 1961. The school had to do without a library for several years due to space constraints. When the most recent additions were made, the library returned. (River Grove School District 85.5.)

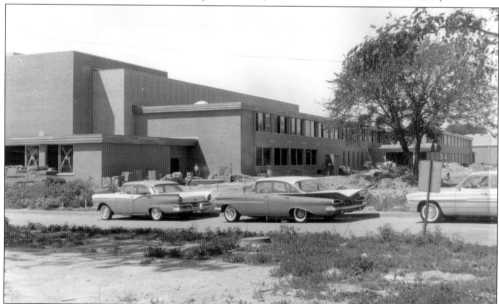

The $350,000 addition to Rhodes School, which was begun in 1957, was still in full swing two years later, evidenced by the 1959 Chevy Biscayne seen in the middle. It was the third addition to the building that replaced the old wooden schoolhouse. The postwar baby and building booms had a huge impact on the west side of the village. (RGHC.)

Harry Busby (presumably standing at left) was the chairman and founder of the Martin Enger and Jim Busby Schools. The goal of these schools was to help mentally challenged individuals, like Harry's son Jim, learn job skills. The Enger School was named after the contractor for his donations and the volunteers he was able to recruit. The schools were built entirely with donations of money, supplies, and labor. They were constructed in 1956 and 1963, respectively, at 8605–07 Arnold Street. (RGHC.)

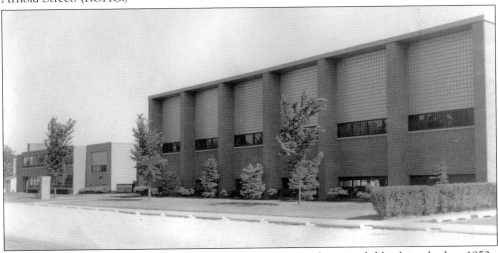

The front facade of Rhodes School looks much the same today as it did back in the late 1950s. The large structure with the glass-block windows seen from Fullerton Avenue was the gymnasium. The style is consistent with mid-century modern design. In 1957, the school had an enrollment of 600 students. The current enrollment is about 670 students. (RGHC.)

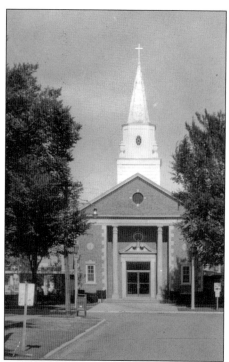

Ground was broken for St Cyprian's Colonial Revival–style church on March 25 1950, and it was dedicated on September 30, 1951. The church replaced the "portable" church, which had served the parish for 21 years. In 2018, the Archdiocese of Chicago decided to close the school after the 2018 term and merge St. Cyprian with Elmwood Park's St. Celestine parish. Both churches were to remain open as worshipping centers for the new combined parish named St. Mother Theodore Guerin parish. (RGHC.)

On April 15, 1956, Cardinal Stritch officiated at the opening of the St. Cyprian School. The 245-by-61-foot, two-story building replaced the school that opened in 1926. The first school began with 150 students, and a growing population necessitated the move to a larger facility. This building also housed a second-floor convent and a rectory. The enrollment in 2017 was only 138 students, and the school was permanently closed by the archdiocese in 2018. (RGHC.)

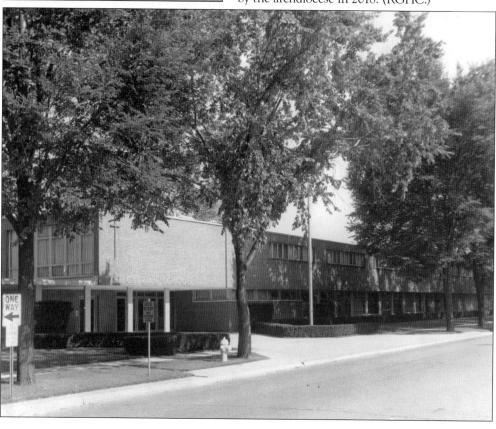

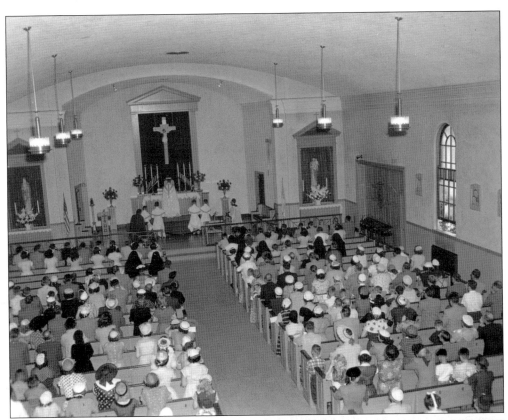

St. Cyprian's current edifice dates to 1951. However, this image was made before the modernization of the altar. The photograph was most likely taken prior to the Second Vatican Council as most of the women, if not all, are wearing hats or some form of head covering and the communion rail is in place. The church cost $165,000 to build and seats 610 people. (St. Cyprian Parish.)

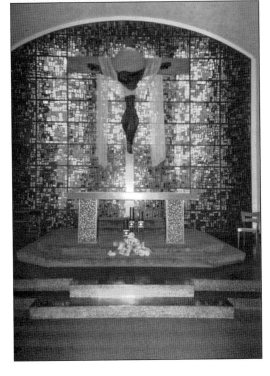

In 1962, Fr. Arthur Douaire, pastor of St. Cyprian Parish, purchased a mahogany crucifix created by Sister Mary Thomasita Fessler; it was carved in a modern style for a hospital. The crucifix inspired the pastor to create a stained-glass window to serve as a backdrop. The resultant mosaic consists of 6,800 glass fragments in 23 colors. Fr. Douaire then created 10 more windows for the rest of the church. (St. Cyprian Parish.)

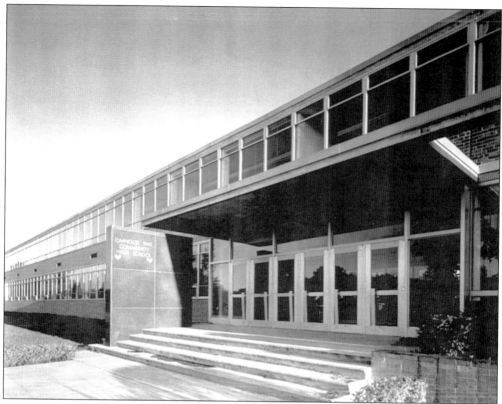

A somewhat confusing arrangement for newcomers is the fact that Elmwood Park High School is situated on land entirely within the Village of River Grove's boundary lines. The school, which opened in 1955, was built on land once belonging to the Oak Park Country Club. Students living across the street cannot attend the school; they must attend East Leyden High School in Franklin Park. (VA.)

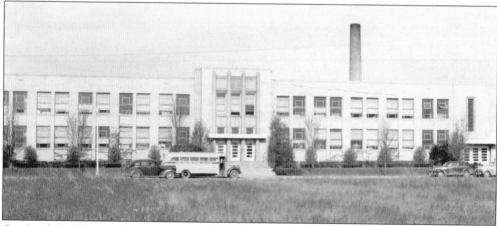

On April 18, 1924, Leyden High School was organized. From the start, students on the west side of the Des Plaines River attended Leyden. Students on the east side had the choice of attending Proviso, Oak Park/River Forest, or Steinmetz. After West Leyden was built, students from the east side of the river were forced to go to East Leyden, seen here on April 24, 1948. The school began a $50 million construction project in 2018. (Franklin Park Library.)

Holy Cross High School opened in August 1961 at 3000 Eightieth Avenue on land that the archdiocese purchased from Elmwood Cemetery. The boys-only school closed in June 2004 and merged with the girls-only Mother Guerin School. In 1972, during major-league baseball's first strike, members of the Chicago Cubs worked out at the Holy Cross gymnasium to the delight of local youngsters. (RGHC.)

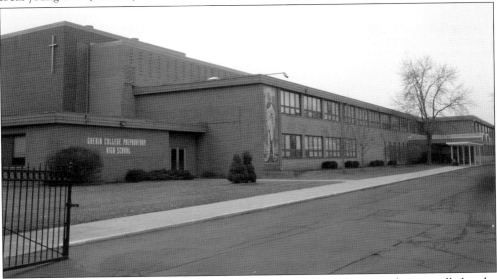

Mother Theodore Guerin High School for girls opened in 1962 with 398 students enrolled under the guidance of the Sisters of Providence The peak enrollment in school history was 1,608 in the fall of 1976. In 2004, after the closure of Holy Cross High School, the two were merged under the name Guerin College Preparatory High School. (Author's collection.)

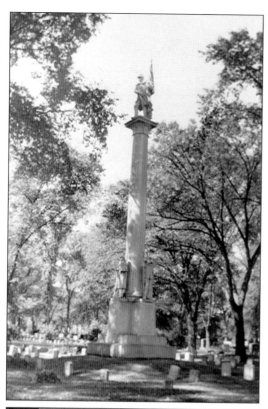

The Civil War soldier and sailor memorial erected in Elmwood Cemetery by U.S. Grant Post 28 GAR (Grand Army of the Republic) on June 28, 1903, commemorates the lives of 200 Civil War veterans buried nearby. The monument is inscribed with 48 Civil War battles and is topped by a Union flag-bearer. The last post of the GAR became inactive in 1948 when the last of the veterans passed from this life. (RGHC.)

Legend has it that the famous actor and comedian John Belushi's body was moved in the dead of the night from Martha's Vineyard to his parents plot in Elmwood Cemetery. While it is difficult to prove, some disrespectful vandals have desecrated the family monument in some bizarre attempt to obtain a collectible from the actor famous for his roles in *The Blues Brothers* and *Animal House*. (Author's collection.)

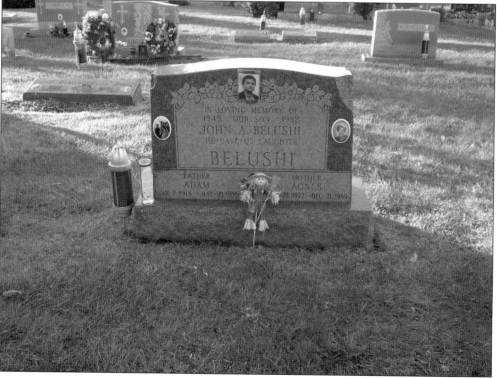

On August 22, 1909, the GAR unveiled this monument directly across from the Civil War Post 28 monument. The granite column was part of the old Chicago City Hall and was a gift from Mayor Fred Busse. About $1,400 was then raised by the Ladies Grand Army Washington Circle to transform the column into a monument. The women later held a bazaar to raise funds to get a life-size reproduction of an Army regular for the top of the monument. (RGHC.)

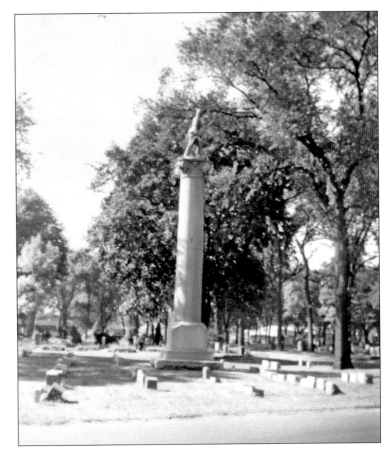

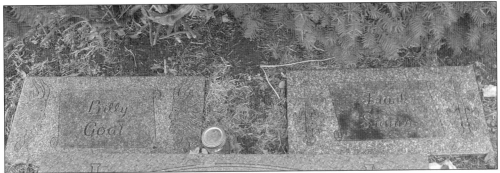

Among the more unique monuments at Elmwood Cemetery is the one inscribed to the Billy Goat. Yes, this is the very Billy Goat that supposedly jinxed the Chicago Cubs from winning a World Series until 2016. The monument rests alongside another for Frank Sianis, brother of Billy Goat Tavern owner William Sianis. Frank died while walking near Madison and Dearborn Streets in 1964 and has another more prominent headstone at his gravesite. (Author's collection.)

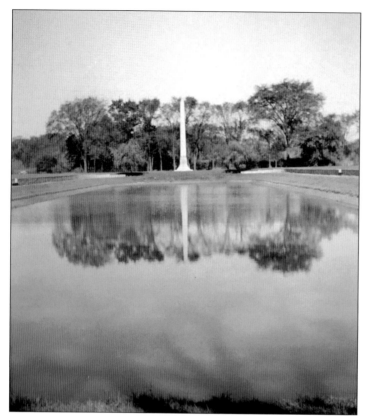

This Washington Monument–styled obelisk, complete with reflecting pond, belongs to William Worthington Higgins. Why he has such a prominent burial site at Elmwood Cemetery is somewhat mysterious. Higgins wrote a 542-page book entitled *World Travel Facts* in 1927. The book has been described as "largely the elaborating of the author's notes taken during a sixteen months' tour of the world." (RGHC.)

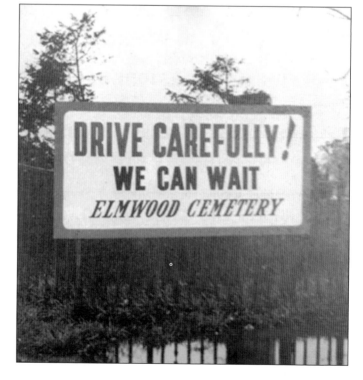

Driving along Thatcher Avenue, countless eyes have been drawn to this sign admonishing reckless drivers. The sign, which is located at the southwest corner of the cemetery, just north of the railroad tracks, has been spreading its important yet tongue-in-cheek message since at least 1948. (VA.)

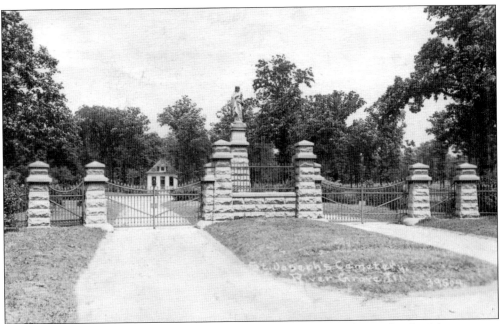

This was the original entrance to St. Joseph's Cemetery. Located on the south side of the cemetery at Struckman Avenue, this entrance allowed direct access for funeral trains from the city via the railroad tracks. Later, these gates were closed and a new entrance was opened at the corner of Belmont and Cumberland Avenues. The gates have been removed, but a couple of stone pillars can still be seen along the fence line. (Author's collection.)

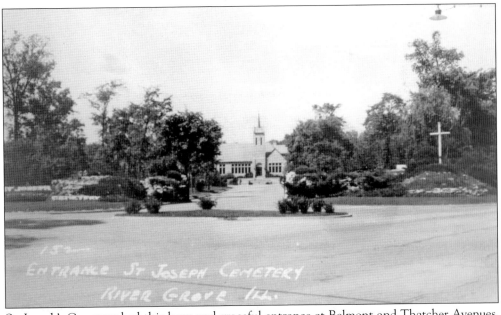

St. Joseph's Cemetery had this large and graceful entrance at Belmont and Thatcher Avenues. The photograph was taken in 1947, but the entrance was closed sometime in the late 1970s or early 1980s. As of 1988, the cemetery had 127,000 burials, among them many Spanish-American War veterans and the creator of Rudolph the Red-Nosed Reindeer, Robert May. (RGHC.)

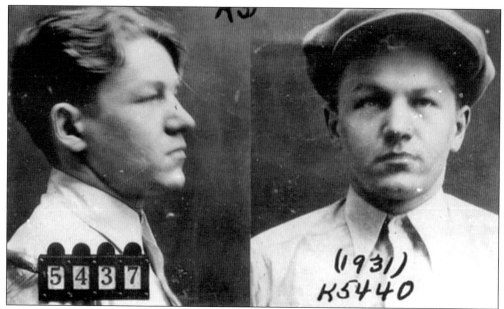

Lester Gillis, also known as George Gillis and Baby Face Nelson, was "Public Enemy No. 1" and an associate of legendary gangster John Dillinger. Lester was laid to rest in an unblessed grave and without a church service on December 1, 1934, at St Joseph's Cemetery. Gillis killed three FBI agents before being killed himself in a gun battle in Barrington. His life is the subject of a 1957 film starring Mickey Rooney. (VA.)

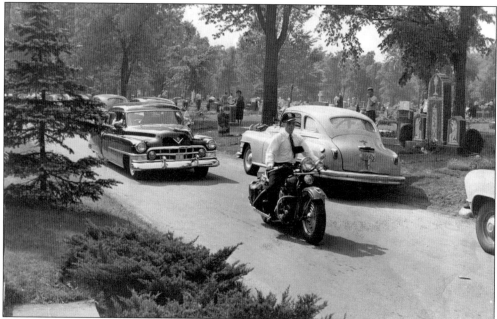

Cardinal Samuel Stritch was the leader of the Roman Catholic Archdiocese of Chicago from 1939 to 1958. This photograph shows the cardinal's motorcade at St. Joseph's Catholic Cemetery on Memorial Day 1951. The cardinal's status as an important figure is apparent by not only his motorcycle escort but also his Cadillac with "No. 1" on the license plate. The cardinal died on May 27, 1958, while in Rome on a papal mission. (Mario Novelli.)

Four

Yesteryear through the Present Day

Nearly 50 percent of River Grove land is occupied by either forest preserves or cemeteries, making it uninhabitable. In the 1940s, there was still farmland on which to build new single-family homes suitable for returning GIs who were getting married and looking for affordable housing in safe communities in the area.

In 1941, there was talk of relocating the Nor-Mann Airport, which stood at North Avenue and Mannheim Road until it was displaced by a Buick war plant. The plan was to move the airport to a 160-acre site of which 40 acres were in southwest River Grove.

In 1946, the original Rhodes School was replaced by a four-room structure on Fullerton Avenue. Within two years, another four rooms were added. The year 1948 brought with it the Manor Homes Inc. development of 200 residences on 40 acres located on both sides of Fullerton Avenue from River Road to Maple Street. Built by Terzo & Company, the homes ranged in price from $10,500 to $12,000; all had the same basic floor plans, but 12 different fronts were offered.

The unity that bound those who had suffered through the Great Depression and the Second World War carried over when the veterans returned home. Clubs and organizations thrived, such as the VFW, American Legion, Lions Club, Loyal Order of Moose, bowling leagues, and Boy and Girl Scouts. These groups created a true sense of community, and many still do.

The largest development in the last 50 years has been the creation and the continued growth of Triton College on the last of the area's farmland. The 1960s also saw the development of the Thatcher Woods shopping area, a large residential project, and the building of two Catholic high schools—one for boys and the other for girls—as well as the village's diamond jubilee.

The 1980s ushered in the Tom Tarpey era, the longest of any administration, which lasted from 1985 until Tarpey's passing in 2004. He was succeeded by Marilyn May, the village's first female president. President May served for 12 years before resigning for personal reasons. Lynn Bjorvik completed May's term as interim mayor until the April 2017 election.

Today, many of the old storefronts and business are gone from Grand Avenue, slowly being replaced by apartment buildings, condominiums, and strip malls. A new era began in 2017, as David Guerin defeated Joseph Giovenco 1,024–470 in the first contested mayoral election in many years.

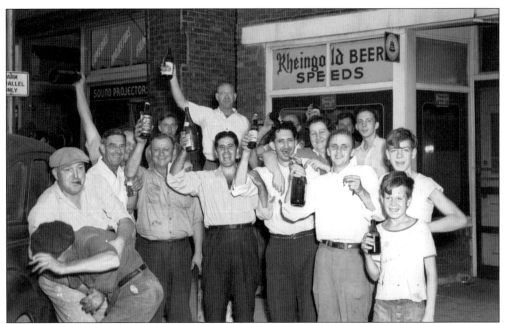

V-J Day, or Victory over Japan Day, August 15, 1945, was celebrated all over the country. The official ending of World War II brought cheers and tears to young and old alike. This group gathered outside the River Grove Tavern on Grand Avenue. Everyone seems to be toasting to victory, except for one fellow who would rather not be photographed. (Franklin Park Library.)

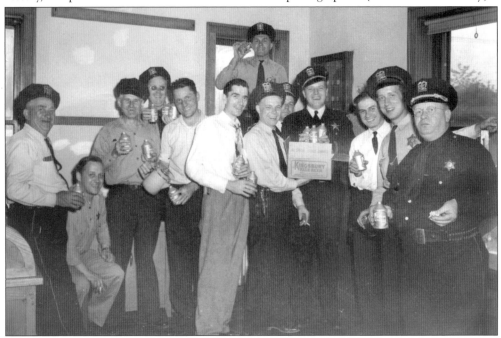

The reason for celebration is not obvious in this undated photograph; perhaps it was the end of World War II. In any case, River Grove's boys in blue were certainly whooping it up with some Kingsbury Pale beer in this lighthearted moment captured for posterity. A closer look will show that nobody is actually taking a drink. (Tarpey family.)

This 1948 map of River Grove shows the southwest section of the village ending at Palmer Street prior to the annexation that extended the village boundary to the Soo Line tracks. Note the comprehensive zoning plan that created the commercial districts that contributed to the small-town feel. Apartment buildings and condominiums have replaced many of the commercial buildings in these areas. (RGHC.)

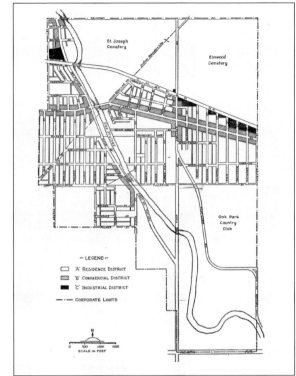

It was rare indeed to see elephants strolling down Grand Avenue, even during a parade. In this undated photograph, one can see several buildings along the north side of Grand Avenue that were later torn down and replaced by a strip mall. The Palm hardware building still stands and is now being converted to lofts. Note the diagonal parking on the south side of the street. (RGHC.)

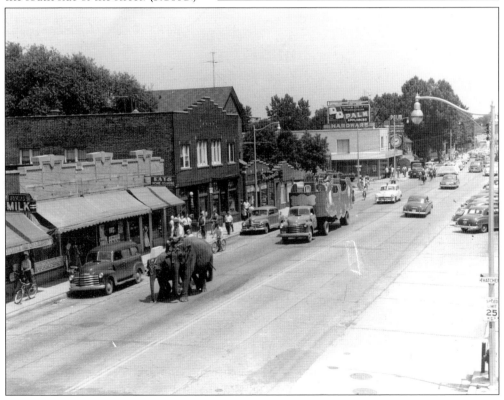

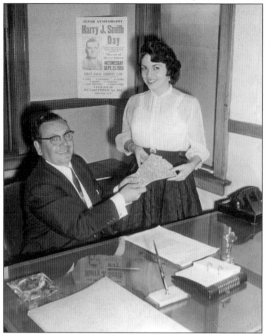

Harry J. Smith Sr. was a master of self-promotion. He created Harry Smith Day to raise campaign contributions. It was a precursor to Mayor's Night. Smith was elected village president in 1945 and held the office for 12 years, until 1957. He also served as state representative from 1956 to 1958 and was a director of the Illinois State Highway Authority. Smith passed away at age 71 on August 23, 1981. (RGHC.)

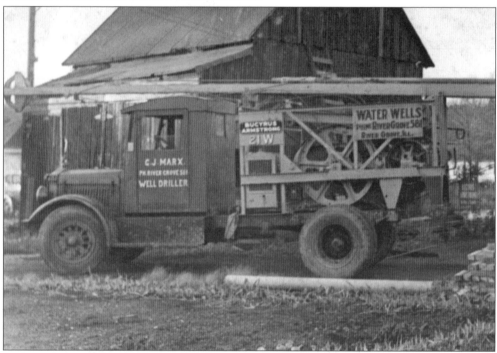

Until the 1940s, River Grove relied on wells to supply water to homes and businesses. Early settlers here were blessed with artesian wells, which were richly supplied by the Cambrian-Ordovician Aquifer underlying the Chicago region. As settlement increased, the water levels began to drop, and as demand continued to increase, water lines stretched from the city to the western suburbs providing Lake Michigan water. One popular artesian well continues to service the area on Irving Park Road between Cumberland Avenue and the river. (RGHC.)

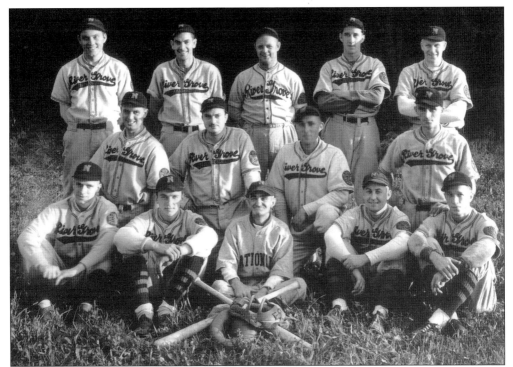

The River Grove Nationals Athletic Club, shown here around the 1930s, began in 1929 with nine members. Joe Wischinia served as the first president. The club for young men organized baseball, bowling, and golf teams. At their peak, the Nationals had 300 members. The baseball team played about 25 games at Oak Street and River Grove Avenue, which became known as Nationals Field. The Nationals still run an active organization despite declining membership. (RGHC.)

Until Mages Bowlarena opened in 1959 at 3111 River Road, the bowling alley at 8465 Grand Avenue was the only game in town. This photograph from 1947 shows some of the teams that competed in bowling leagues or tournaments. Mages featured 48 lanes when it opened. It is still in operation as Brunswick Zone River Grove Lanes. (VA.)

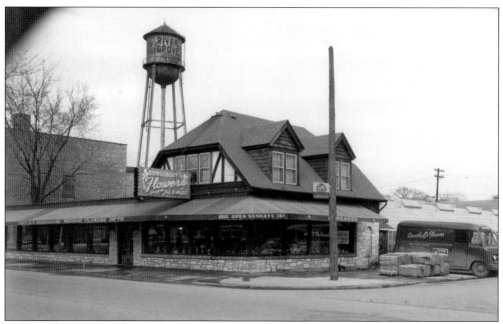

After a few years in its first River Grove location, Quasthoff's Flowers moved across the street to the east side of Thatcher Avenue south of the railroad tracks. The water tower looks a little weather-beaten in this photograph, but it was repainted by the 1960s. In local neighborhood newspapers, the business often posted a floral illustration containing the catch line "Sympathy Flowers—guaranteed fresh." (Harry Schneider.)

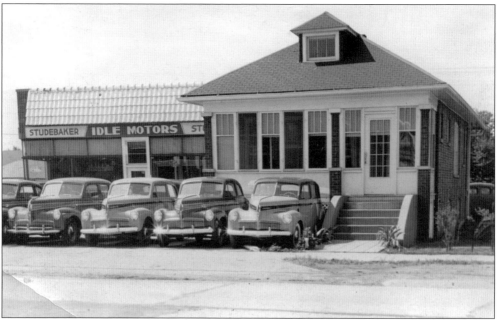

Ken Idle's Studebaker dealership, shown here, was located at 8201 Grand Avenue from 1941 until 1944. Idle then began selling Chrysler and Plymouth cars for the next six years before relocating his dealership to 8401 Grand Avenue, at the corner of Thatcher Avenue. Idle had his first car lot at 7246 Grand Avenue in Elmwood Park prior to moving to River Grove. (RGHC.)

Andy Madsen was a postal carrier in River Grove from 1942 until New Year's Eve 1975. Born in River Grove in 1924, Madsen witnessed more than a few interesting events—like the time he watched the funeral cortege of Lester Gillis, also known as Baby Face Nelson, from his perch in a mulberry tree along the railroad tracks; or when he saw a couple of men set a diversionary fire at the monument company so they could rob the bank. (VA.)

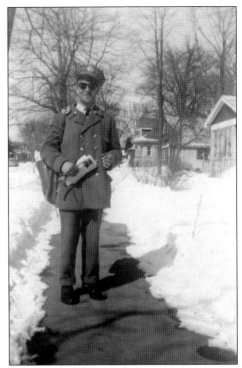

The Shell station at 2434 Thatcher Avenue, the second on that site, is now home to Dave's A-1 auto repair business. The station was built by Bill Woods, a volunteer fireman who would respond to the fire department in his tow truck whenever the fire whistle sounded. The gas station served as a refuge for Bill's sons Curt and Paul and their friends. They would spend summer days building go-karts and, later, working on their own cars. The Firestone building is now the site of Char's K-9 Kleeners, a dog-grooming business. (RGHC.)

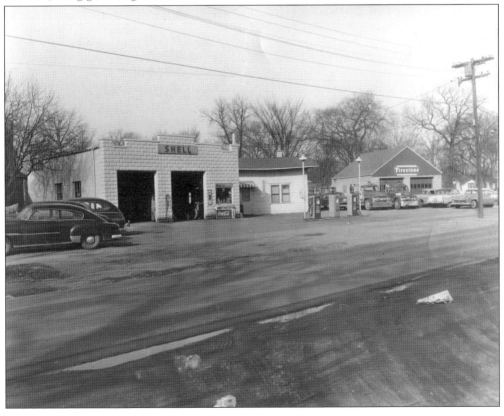

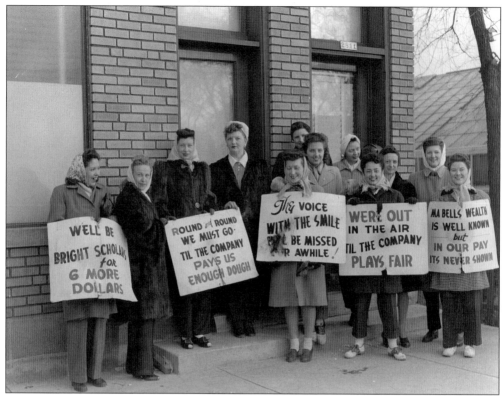

The telephone operator's strike of 1945 produced some clever slogans for those walking the picket line. Those picketing are identified as (left to right) ? Mazulla, Cornelia Boerema, Grace Hachmeister, Helen Burmeister, two unidentified, Betty Quasthoff, unidentified, Florence Puchini, Arvis Emigh, Lavergne Jageski, and Adeline Matusek. At the time, the use of dial telephones was steadily increasing over manually operated lines; however, the new technology still required many operators to handle calls of a "special nature," such as long distance connections. (Franklin Park Library.)

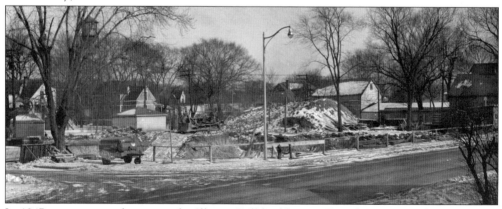

In 1947, construction began on the Illinois Bell building at Grand Avenue and Tarpey Lane (formerly Park Avenue) to replace the old phone exchange on Thatcher Avenue that was gutted in a 1946 fire. Two additional wings were added to the building in 1956 that handled 22,000 numbers in River Grove, Franklin Park, Elmwood Park, Schiller Park, and Norridge. The additions allowed for 5,500 new numbers. (Franklin Park Library.)

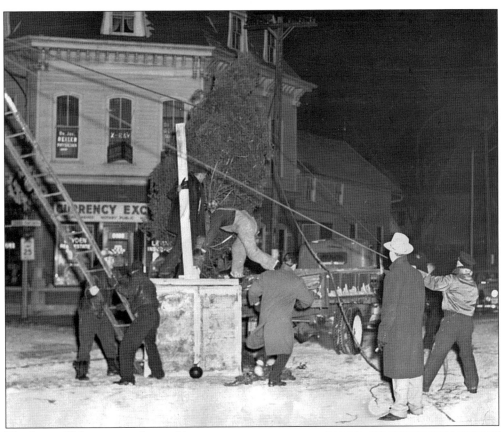

The Lions Club appear to be working at a brisk pace as they put up the village Christmas tree. The expediency is warranted as they annually set the tree up in an intersection. Legend has it that every year someone would crash into it. For the past several years, the village Christmas tree has been located nearby on the grounds of the River Grove School. (RGHC.)

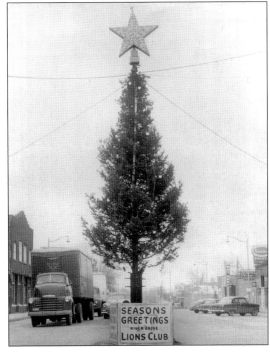

The village Christmas tree sponsored by the Lions Club was erected in the center of the intersection of Grand and Thatcher Avenues for many years. The Lions Club is the world's largest service organization. A focus of the Lions has been to fight blindness and vision impairment, which was a challenge given to them by none other than Helen Keller. (RGHC.)

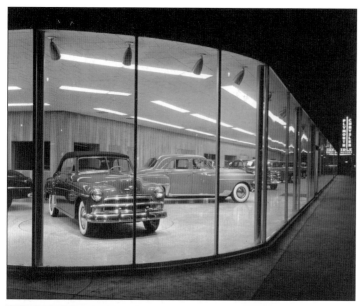

The 1950 Plymouth Special DeLuxe convertible with a price tag of $1,982 was the second-most expensive model in the Plymouth line that year and was one of 12,697 built. It was displayed on a slowly revolving turntable at Idle Motors, located at the southwest corner of Thatcher and Grand Avenue. After the dealership closed and was purchased by Polk Brothers, a piano player would often slowly rotate while playing for the customers. (RGHC.)

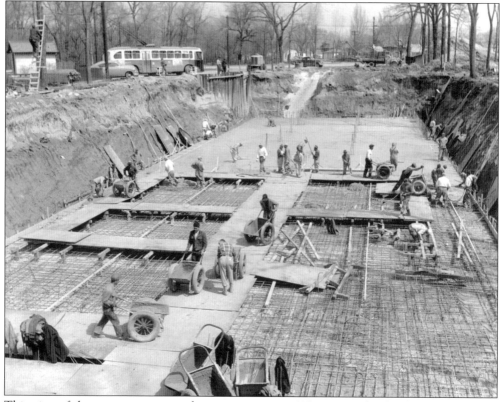

This view of the water reservoir under construction in 1954 just south of Belmont Avenue on Thatcher Avenue shows a trolley bus in action. Trolley buses were electric buses that were tethered to overhead power lines. The buses ran along Belmont Avenue from 1949 until 1973. The blizzard of 1967 sealed the fate of the buses, as they were unable to maneuver around stranded and double-parked cars in the era before snow routes. (RGHC.)

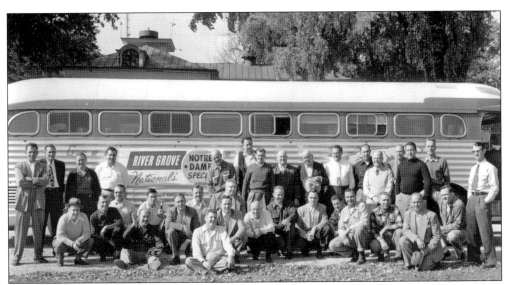

The River Grove Nationals are dedicated to community service. In the 1940s, they sponsored an ice show on a lot along Grand Avenue between Erie and Clinton Streets. In 1971, the Nationals, along with several other organizations, sponsored an Easter egg hunt in the forest preserve near American Legion Hall 4320—eggs and all. Here, they are having fun on a Notre Dame football trip on October 22, 1955. The final score at Purdue's Ross-Ade Stadium in West Lafayette, Indiana, was Notre Dame 22, Purdue 7. (Mario Novelli.)

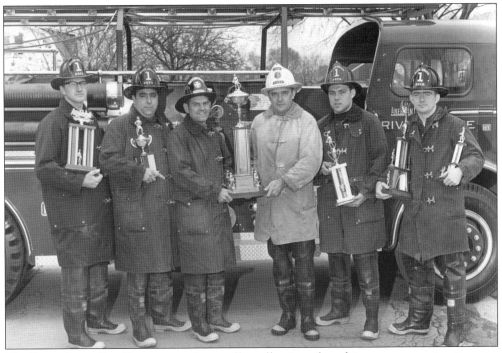

The River Grove Fire Department shows off a collection of trophies won competing in water fights. In a water fight, teams use their fire hoses to move a barrel, which is usually suspended from a wire. From left to right are Chuck Liss, Ralph Canino, Lou Schneiderwind, Hank Kohl, Jack Domschke, and Larry Casserly. (Larry Casserly.)

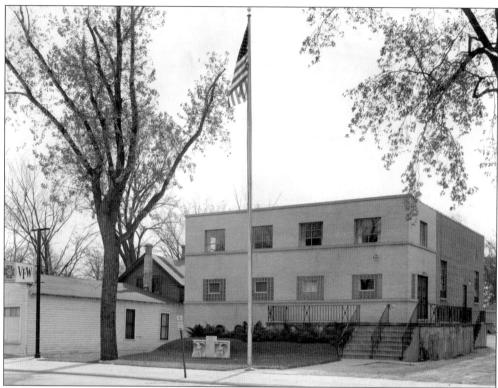

The Central Leyden VFW Post No. 5979, located at 8527 West Grand Avenue, was a hub of activity in the 1970s with dances, spaghetti dinners, and even film screenings. Elm Heating and Cooling, a Grand Avenue fixture since 1953, purchased the building in 1999. The VFW sold the building as membership began to decrease and now meets at the village recreation hall. (RGHC.)

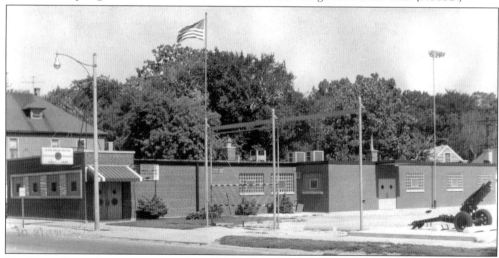

The River Grove American Legion Post No. 335 began on December 7, 1931. The men originally met at Ostrowsky's garage on Maple Street. In 1952, they erected the building on the current site at 8664 Grand Avenue. The structure was expanded in 1961. Despite the merger with the VFW, a declining membership inspired the post to donate its building to the Village of River Grove on October 16, 2008, to serve as the village recreation hall. (RGHC.)

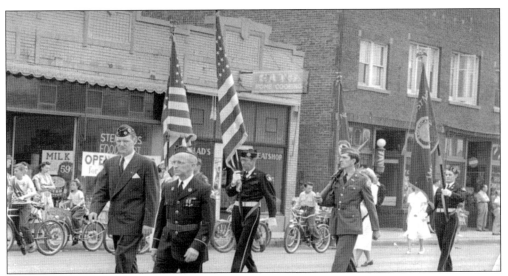

Memorial Day parades were annual event for River Grove from the earliest days of the village through the 1960s. The parades would often terminate in the Elmwood Cemetery. This view is looking across Grand Avenue from the south side toward what is now the JJ Pepper strip mall. Stein Brothers Foodmart is in the background. (RGHC.)

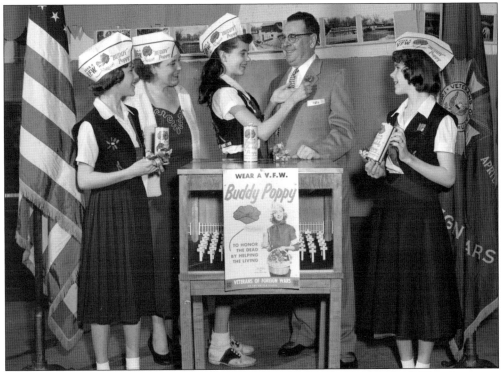

The poppy became the international sign of eternal sleep after World War I. The American Legion began using the red crepe poppy here in the United States, but the Veterans of Foreign Wars (VFW) coined the name "Buddy Poppy" to signify that theirs were made by disabled and needy veterans to honor their fallen comrades. In this photograph from May 23, 1956, a young volunteer is pinning one onto Mayor Harry Smith. (RGHC.)

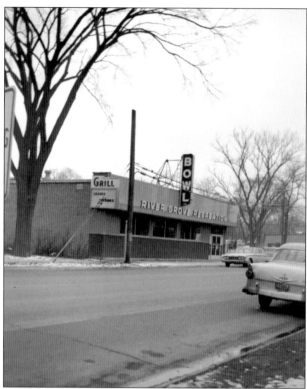

Built in the 1950s, the bowling alley at 8465 Grand Avenue was gutted by fire in 1963. The bar attached to the bowling alley was originally a pool hall but became known as the Penny Lane Pub. The namesake bar was made with pennies imbedded in Lucite. It was closed for good in 2007 and remained empty until the structure was torn down in 2017. Luxury apartments are being built on the site. (RGHC.)

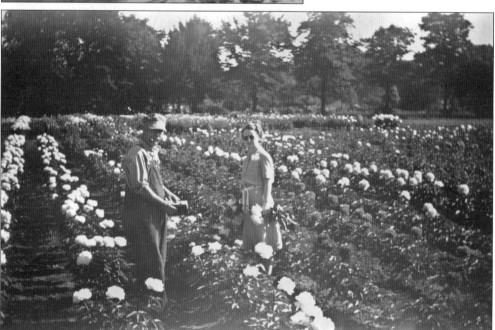

For many years, Arthur Murawska ran the River Drive Peony Garden, located on five acres of land on River Road at 8740 Ridge Street. Murawska, an engineer for the Milwaukee Road railroad, became nationally known for his peonies. He developed and named 43 different types of flowers. (Lisa and Gloria Murawska.)

In 1955, Consolidated Foods built a huge facility at Palmer and George Streets. The building was, and probably still is, the largest single structure in the village. It was built as a processing and distributing center for several area grocers, including the Royal Blue Stores. The building is currently home to Regent Products Corp., which supplies dollar stores. (VA.)

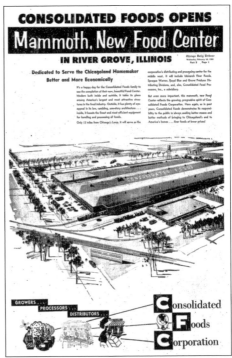

Mayor Harry Smith (second from left) presented Nathan Cummings (center) of Consolidated Foods the key to the city. The grand opening of the facility, built on 33 acres, took place Wednesday, February 16, 1955. The event was attended by 2,000 guests and celebrities. Sonja Henie and Cesar Romero are seen on the right of the photograph. Ann Miller and Esther Williams were also in attendance. (Harry Smith Jr.)

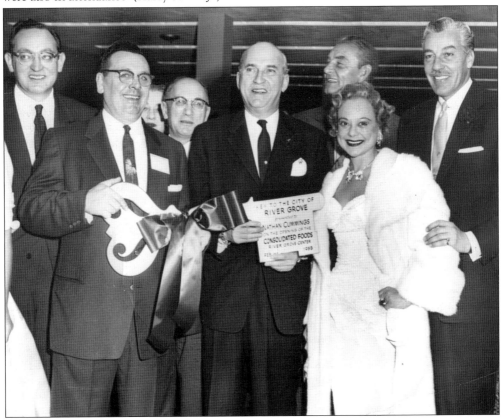

The ground breaking for the new St. Cyprian School and Convent was a well-attended event. The Nationals had occasionally used the site as an ice-skating rink. Cardinal Stritch officiated at the dedication of the facility on April 15, 1956. In 2018, the Chicago Archdiocese announced that the school would be closing permanently at the end of the school year after serving the community for 91 years. (St. Cyprian Parish.)

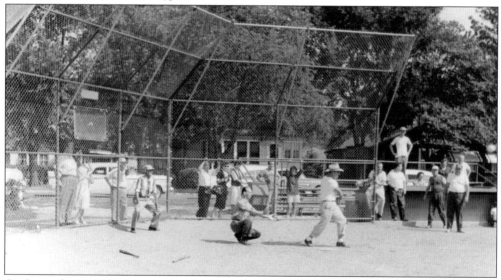

On September 6, 1958, photographer Ray Steciak captured a moment from a ball game at Scheltens Field. The field, located at Maple and Herrick Avenues, is named for Frank Scheltens, who was killed in Korea at age 22. At the dedication in 1954, which included a parade, village president Harry Smith said, "As long as this field is for the youngsters of our community, I feel it should be dedicated to the memory of one of our boys who has paid the full price of war." (RGHC.)

Polk Brothers held its grand opening on November 24, 1956, in the former Idle Motors Building at Grand and Thatcher Avenues, shown here in March 1962. It was described as a "supermarket type" store with hi-fi records and a jewelry department in addition to its electronics and appliances. During the 1960s, thousands of illuminated five-foot-four plastic Santa Clauses and snowmen adorned area homes during the Christmas season; they cost $5 along with a purchase. (RGHC.)

The Grand River Sunoco station held its grand opening in May 1962. Mayor Richard J. O'Connor, seen in shirt and tie, holds the balloons. In 1976, the station at 8450 Grand Avenue, then owned by Farah Bakasiva, offered to start selling milk and bread due to the closing of the nearby Village Dairy. (RGHC.)

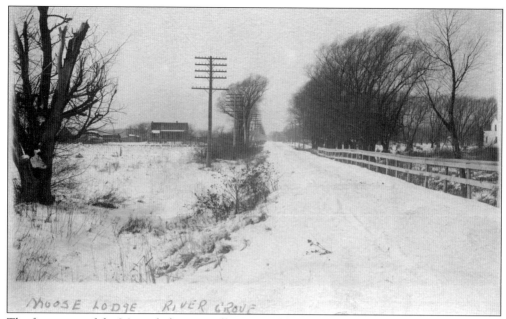

The future site of the Moose lodge was still very rural looking prior to 1938, as seen in this view facing west from River Road and Fullerton Avenue. Officially called the River Park Moose Lodge, the structure located at 8601 Fullerton Avenue harkens back to one of the earliest names of the community. The building was erected on the southwest corner of the intersection, in the left side of the photograph. (RGHC.)

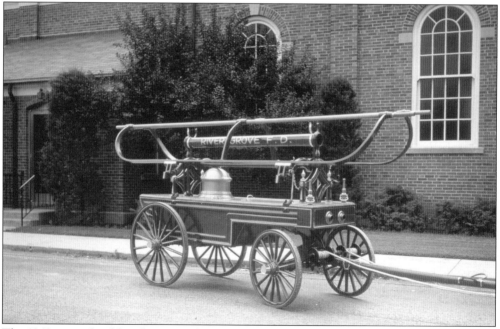

The 1848 squirrel-tail hand pumper that once belonged to Fred Von Rath has been on display since the early 1960s. It takes several men on each side to work the pump, so they had to swap each other out every two to three minutes. In 1963, the fire department demonstrated how it worked to the public. (River Grove Fire Department.)

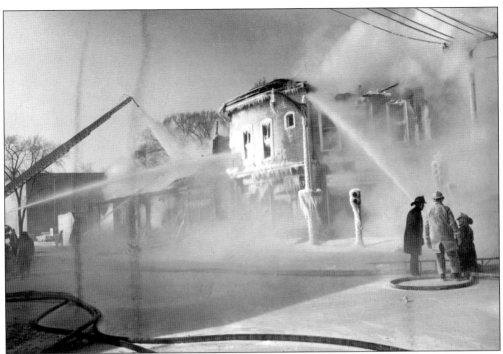

It was a brutally cold night when River Grove lost its greatest landmark, Senf's Hall. The temperature on January 23, 1963, reached 17 degrees below zero. Seventy men took 12 hours to fight the fire using 750,000 gallons of water. Frostbite from the subzero temperatures became a very serious concern for the firefighters. (RGHC.)

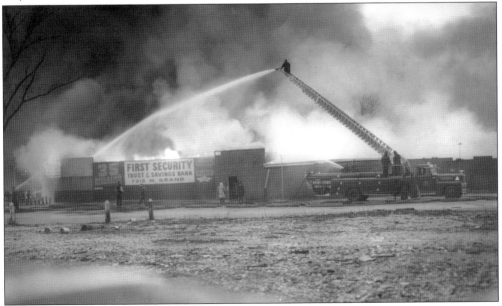

The second big fire of 1963 destroyed the interior of the River Grove Recreation building at 8465 West Grand Avenue. The owners rebuilt the gutted structure and reopened in 1964. The building housed 16 bowling lanes, and during its heyday in the 1970s, famous bowling greats such as Earl Anthony, Dick Weber, and Carmen Salvino competed in tournaments there. (Larry Casserly.)

The 1963 diamond jubilee was kicked off with a coronation ball held in the recently opened River Park Moose Lodge hall. Michael Schube, a professional photographer and member of Lodge No. 378 for over 25 years, took this photograph of the building. The hall at 8601 Fullerton Avenue replaced the old Moose hall that was at 8301 Grand Avenue. (RGHC.)

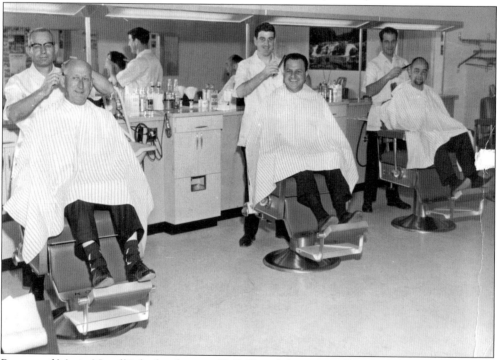

Patrons of Mario Novelli's barbershop, at 8345 Grand Avenue, will undoubtedly recognize the interior of Armando's Barber Shop. This photograph was probably taken at the grand opening back in 1963; from left to right are (standing) Armando Carbone, Guilo Parducci, and Fran Romanelli; (seated) Mayor O'Connor, unidentified, and Tim Vavra. Novelli began working in this shop in 1978 and bought it in 1998. Romanelli, a produce man from across the street, was recruited to pose as a barber for the photograph. (Mario Novelli.)

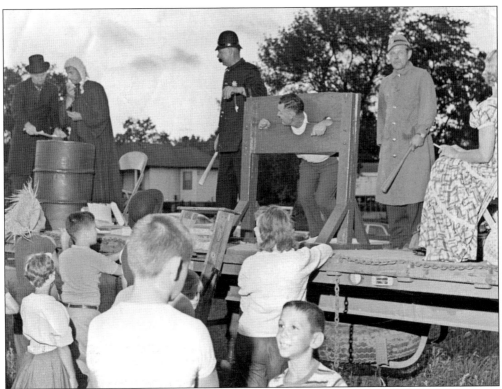

During the 75th Jubilee in 1963, a kangaroo court (on a flatbed truck) detained men who did not grow facial hair. Shown here are Bud Leder locked in the stocks awaiting his judgement while Bill Nelson (right) and Roy Grime (?) get ready to administer the sentence. The mock trials were part of the four-day-long celebration. (RGHC.)

When touch-tone phones made their debut in Pennsylvania on November 18, 1963, they were considered "space-age technology," but it was not until the 1980s that touch-tone replaced rotary phones in the majority of households in the United States. Ultimately, their ability to communicate with automated systems led to further advancement such as mobile phones. (Tarpey family.)

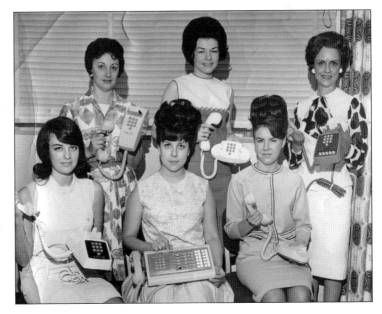

The River Grove Grandmothers Club Charter No. 574 was just one of many community organizations that residents could join. This photograph is from October 6, 1965, but in 1963 the officers of the club had included, Bertha Riegler as president, Verna Werner as vice president, Julia Anderson served as secretary, and Elsie Voss was the treasurer. (RGHC.)

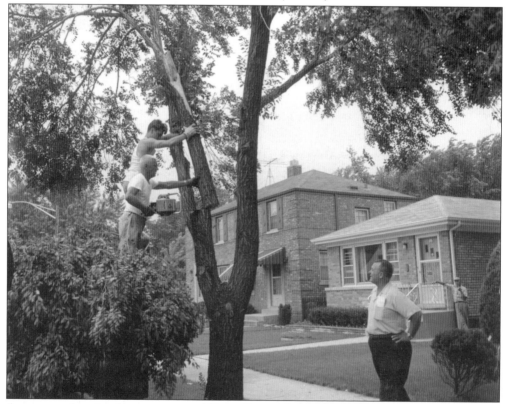

As one can imagine in a town named River Grove, the public works department is kept busy maintaining the parkways. Back in the days before OSHA regulations, O.R. Fisher (near right) supervises as Noel ? wields a chain saw and Bruce Sievert catches the limb. These days, all three would be wearing hard hats and using a cherry picker or bucket truck to ascend into the tree canopy. (RGHC.)

People can be as memorable as places, even when they are anonymous. Countless commuters purchased their daily newspapers at the southwest corner of Thatcher and Grand Avenues from Art Hornig, who operated his newsstand there from 1962 through 1982 rain or shine. This photograph is from Sunday, March 11, 1979. At the time, the *Chicago Tribune* and the *Chicago Sun Times* both cost a mere 60¢. (Art Hornig.)

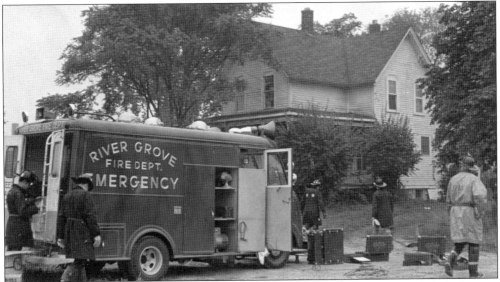

Fires were a common occurrence on college campuses in the 1960s, but the one that occurred on September 9, 1969, on Triton College's campus was a planned training exercise that included 70 firemen from the towns of River Grove, Franklin Park, Northlake, Stone Park, Elmwood Park, and Rosemont. The historic farmhouse was located just north of Hemingway Drive along Fifth Avenue. (River Grove Fire Department.)

The River Grove Post Office, seen here in 1973, was located at 8256 West Grand Avenue until the current building at 2728 Clinton Street was opened in 1993. The new building provided several amenities that the old one did not, including a large parking lot. The old building is currently home to Cugini Distribution LLC. The White Tavern, a very old establishment now known as Tucker's on Grand, is seen on the left. (Schiller Park Historical Society.)

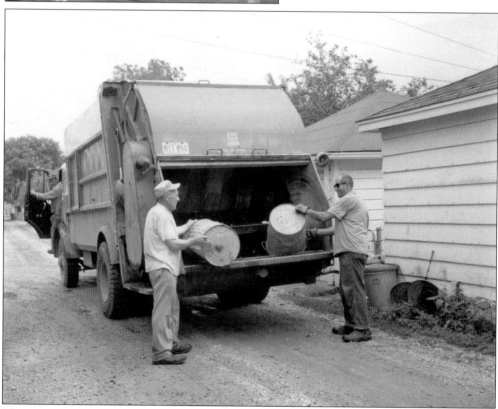

The transition to uniform 96-gallon cans has changed the once arduous task of garbage collection. What a three-man team once handled can now be done with one man and specially equipped trucks. Back in the days of cinder alleys, anything could be thrown in the garbage. Today, homes are also furnished with 35-gallon blue-lidded cans for recycling glass, plastic, and paper items. (RGHC.)

At some point during or prior to the Elmer Wolf administration, as proved by the sign, the village adopted the motto "Village of Friendly Neighbors." It has a nicer ring to it than the first village motto touted by the business association, the poetic and pleasant "Don't be a Rover, be a River Grover." This welcome sign stood at Webster Street and Fullerton Avenue. (Triton College.)

The nursing class of 1969 is pictured on graduation day. Triton College began a nursing program in 1966. The first classes met at the West Leyden campus at 1000 North Wolf Road in Northlake. The students received clinical experience at West Suburban Hospital. The popularity of the program caused Oak Park Hospital to close its nursing school in 1971. (Emil Warncke photograph, Triton College.)

Local hero and the last man to walk on the moon, Eugene Cernan returned to the area along with his mother to unveil a statue of himself at the dedication of his namesake space center at Triton College on May 23, 1974. Ceramic instructor Kenneth Heffley created the eight-foot-tall aluminum statue. The space center also featured a planetarium and was known for its laser light shows. (Triton College.)

This aerial photograph provides a good view of Triton's quad, or "the mounds," as they are affectionately known. They provide a good place to take a break from studies. The original Cernan Space Center is the domed structure on the right. It was only open for eight years before being closed due to structural issues. An entirely new space center was built and opened on June 23, 1984. (Triton College.)

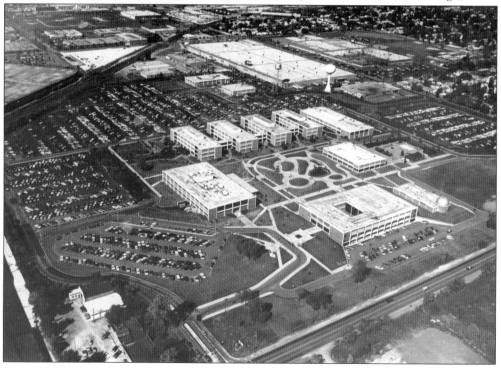

WRRG 88.9 FM is Triton College's flagship radio station. The station's first broadcast was at noon on March 10, 1975. Julie Coleman is seated at the microphone in this photograph from 1986. Staffed by students, the station features community and school news, along with sporting events and all genres of music. (Triton College.)

This Bill Whelan photograph from 1982 shows Larry Jackson sliding into home at the Triton baseball field, which was built in 1976 and renamed Symonds-Puckett Field in 1989 in honor of former head coach Bob Symonds and Triton star and major-league baseball Hall of Famer Kirby Puckett. Former Chicago White Sox player Lance Johnson also played baseball at Triton College from 1981 to 1983 in the same outfield as Puckett. (Triton College.)

The Triton Troupers Circus was begun in 1971 by Jeff Austin. The troupers are actually students and adults who take courses as part of continuing education. The circus had its first performance in 1972 and has continued to the present day. The circus features clowns, jugglers, feats of strength, and other stunts. The 2018 edition runs about two hours. (Triton College.)

All eyes were to the sky on August 21, 2017, for the first total solar eclipse seen in the mainland United States since February 1979. The event, also known as "the Great American Eclipse," had people lining up at the Cernan Earth and Space Center to purchase special viewing glasses. The center also held a viewing event on the campus. Untimely clouds somewhat spoiled the event. (Author's collection.)

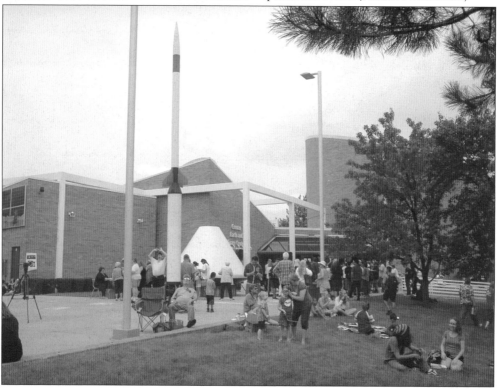

This jail cell seems like a place that could have held the Count of Monte Cristo. Actually, this photograph from September 17, 1975, shows one of the three cells in the old River Grove police station. The cells were found to be substandard in 1971 by the Illinois Department of Corrections. They served until new facilities opened in January 1977. (RGHC.)

Members of the police department of River Grove, led by Chief Tom Tarpey (first row center) look quite spiffy in 1976 with their shoulder cords and white ascots on the steps of the old village hall. The days of revolvers and wooden billy clubs are long gone. Today's officers benefit from modern technology, including bulletproof vests and Tasers. (RGHC.)

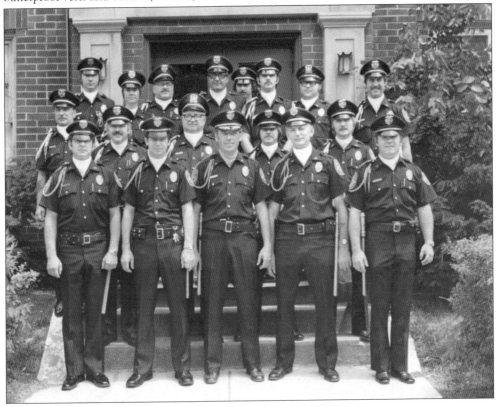

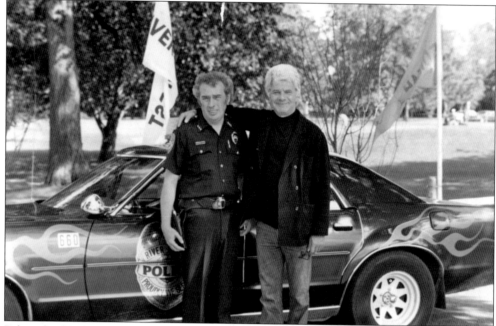

Police chief Tom Tarpey poses with actor Dick Shawn in front of his famous hot-rod police car at the Oak Park Country Club. The car, which was adorned with mag wheels and painted flames, was featured in hot-rod magazines. Chief Tarpey used the car to draw attention to his underfunded police department. Shawn was known for his role as Sylvester Marcus in It's a Mad, Mad, Mad, Mad World, among others. He died onstage in 1987. (RGHC.)

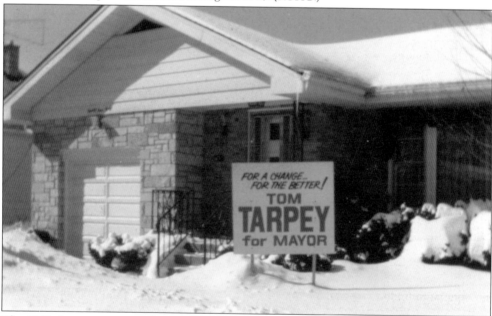

The 1985 election season in River Grove was known as the war of the signs. This was just one of over 800 signs posted in the village. In the end, former police chief Tom Tarpey defeated the incumbent Elmer Wolf (who served as mayor from 1973 to 1985) by just over 400 votes in the hotly contested battle for the mayor's seat. The final tally was 2,381–1,948. (Tarpey family.)

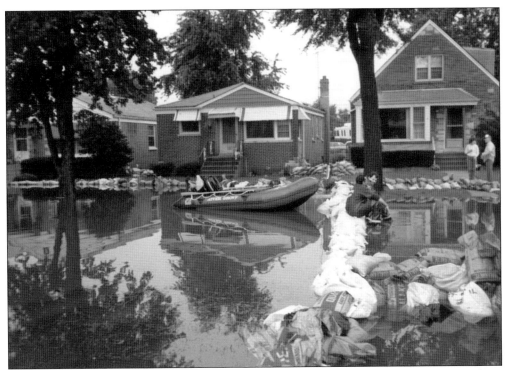

It is not very often that boats park on the 8700 block of Herrick Avenue, but in October 1986, they could be seen along with sandbags all along River Road. A week of heavy rains forced the river over its banks and more than 25 families had to be evacuated. Floods again tormented weary residents 19 months later, in August 1987. (Tarpey family.)

Harry Smith Jr. has emceed each and every Mayor's Night, a River Grove tradition since 1964. Drawing celebrities and politicians, the annual event started back when Stanley Boyle was mayor. Corned beef and cabbage was the traditional Irish meal. Mayor Tarpey (center), a Chicago Bears fan, poses with former Chicago Bears, from left to right, Ron Rivera, Johnny Lattner, Tom Waddle, and Jim Morrisey at the 13 Colonies banquet hall. (Tarpey family.)

Music and fun often emanate from the gazebo, which plays host to many concerts and community events throughout the year. A landmark of River Front Park since the mid-1980s, the gazebo is the park's centerpiece. It straddles Carey Avenue just before the bend on Ditka Drive (once River Terrace Avenue). The street was renamed in honor of Coach Mike Ditka after the Chicago Bears won the Superbowl. (RGHC.)

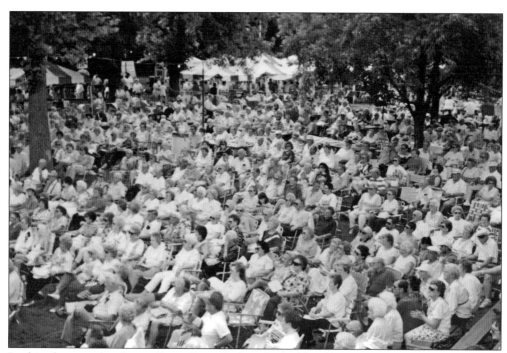

In this photograph taken at River Front Park, it looks like all of River Grove dusted off their aluminum folding chairs to attend a concert at the gazebo. The occasion is mostly likely the River Front Fest in the early 1980s. Built by closing off River Terrace Avenue after the few homes on the street were demolished, the park continues to feature concerts and events. (Tarpey family.)

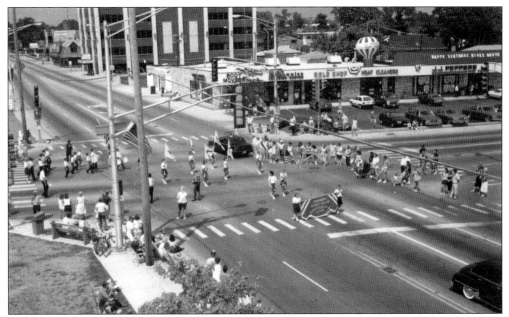

The 1988 centennial parade is seen from atop the River Grove School. JJ Peppers marked the occasion with a rooftop message. The parade, which enjoyed picture-perfect weather, was just one of several big events over the weeklong celebration. (River Grove School District 85.5)

In 1990, the village had a local metal shop fabricate metal planters for the railings of the Grand Avenue Bridge. Each year, volunteer's help to fill them on the village's annual planting day. In the foreground is Betty Stein, a "professional" village volunteer who also worked with the historical commission. Betty was the wife of Frank Stein, whose father operated the meat market on Grand Avenue. (Tarpey family.)

The River Grove Youth Council gives the young people of the village an opportunity to learn how local municipalities and governments operate. On the back wall is a wood carving of the village logo done by Mario Novelli Sr. It contains seven symbols—the river, the trees, a canoe, a headdress and tepee, a Bible, a pair of hands, and a spiral motion signifying a movement to the future. (Tarpey family.)

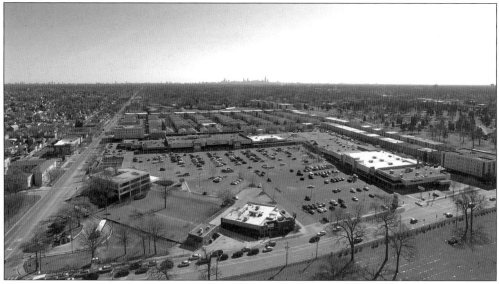

In late 1965, construction began on the 19-acre Thatcher Woods Shopping Center seen in this recent aerial view. Zayre was the largest store in the complex, which also featured a Dominick's and Walgreens. The lineup of stores has changed over the years and currently features a Binny's Beverage Depot, Rich's Fresh Market, Dunkin' Donuts, Goody's Fast Foods, the Hanging Garden Banquet hall, and Jane's Hallmark Shop, among others. (Author's collection.)

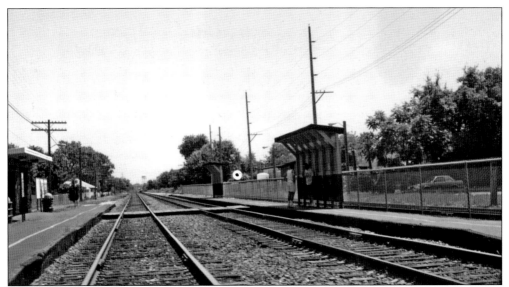

Clearly, the golden days of travel by rail had ended by the 1980s, when these shelters serviced the local rail stop. Local officials worked with Metra to build a new station on the west side of Thatcher Avenue, north of the tracks. The Elmwood Park water tower can be seen in the distance. (Tarpey family.)

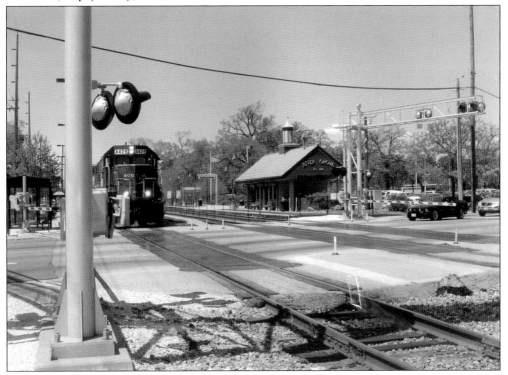

In 2010, Brent Leder took this photograph with a view looking west showing an approaching freight train. In the background is the Metra train station, dedicated on June 27, 1995. The station, designed to look like an old-fashioned train depot, was a welcome improvement over the shelters seen in the previous photograph. (RGHC.)

The River Grove School celebrated Arbor Day 2010 by planting an American elm. The new variety is resistant to Dutch elm disease. The disease devastated the local population of majestic elms that once flourished in the area. Most had to be cut down in the early 1970s. (River Grove School District 85.5.)

The village of River Grove became an official Arbor Day Foundation Tree City in 1996 and has received this honor every year since, including 2018. The program was begun in 1976. A municipality must meet four criteria in order to claim the honor, including having a tree board, a village tree ordinance, a forestry program, and observation of Arbor Day. Brent Leader and Tracy Aller are holding the flag. (RGHC.)

Five

LOCAL TREASURES

A town is more than just its inhabitants, homes, or businesses. It is the collective experience of places, events, and people gathered together at a particular moment in time. River Grove is known outside of its borders by many people, though some may not even know where they are—just that they are at the Hala Kahiki or Triton College. Some thought they were in River Grove when at Kiddieland or Russell's, but those belong to neighboring villages.

In the early days, many areas were unincorporated and village borders changed without signage. For example, Sunset Stables, which was in existence from the 1940s until the early 1980s, was often listed as Maywood, Illinois, even though it was just north of Kiddieland. To complicate things, people used different names for the community, with Glendon Park, Turner Grove, and Cazenovia being examples.

River Grove has three main thoroughfares—Grand Avenue, River Road, and Thatcher/First Avenue. Along these roads, many establishments thrived that were dedicated to leisure and/or consumption of food and beverage. Each place was unique in its own right, with characters to boot, like the tightrope-walking monkey at Mary's Tavern or Adolph Hamann's pet raccoon that would sit at the bar in the White Tavern (now Tucker's) and eat popcorn.

Some places have stood the test of time, like Gene & Jude's and Hala Kahiki; or had great runs only to meet the wrecking ball, like Senf's Hall, Thirsty Whale, Village Dairy, and the River Grove Bowl. Yet others survive in other incarnations, Kirie's (River Café), Idle Hour (Grand Stop), and the Wonder Inn (Home Stretch Inn).

Other place have changed names or vanished from existence, like the Deer Head Inn; Cuephoria or Marzullo's Drug Store, which is now Athletico; or Paul's Barber Shop, currently Blondies diner.

In 1965, construction began on the Thatcher Woods Shopping Center. Although never used for burial purposes, the grounds were originally part of the Elmwood Cemetery. Today, that area is a shopper's delight with a variety of stores as well as places to eat like D'Agostinos restaurant, Goody's, and Dunkin' Donuts.

While some places now only exist in memories, this chapter features a few of the more memorable places and locations.

The River Terrace movie theater was located on Grand Avenue near River Terrace (now Ditka Drive). It had one screen and 235 seats and operated from 1927 to 1932. This flyer from 1927 is one of the few remaining items from its glory days. The main feature playing was *The Unknown*, in which Lon Chaney stars as an armless, knife-throwing circus performer. (RGHC.)

Kirie's Restaurant at 2826 Thatcher Avenue began in a wooden structure that was a former trading post. In 1903, a whole family could eat for 25¢. Opened by Charles and Julia Kyriazopulos, the original building was destroyed by a fire. The current building was built in 1911. It was known as Kirie's Foxhead Inn in the 1930s and 1940s, Mr. B's in the 1970s, the Loon in the 1990s, My Way in 2011, and is now the River Café. Over the years, the location has been an occasional hangout for those in the Chicago Outfit. (Author's collection.)

By the time this photograph was snapped in 1959, Kirie's Restaurant had been in business for 56 years. The view is looking west from across Thatcher Avenue toward the garage, possibly a former barn, at the back of the parking lot. The alley is between Arnold Street and Center Avenue. (RGHC.)

This postcard of the interior of Kirie's from the late 1940s/1950s is likely how it looked in 1934 when four gunmen were holding up 200 patrons. Hearing a couple of warning shots fired by the gunmen, 13-year-old Louis Kyriazopulos grabbed a shotgun nearly as big as himself and fired from an upstairs window at two lookouts below. The bandits fled with only $25 and dumped their shot-ridden and bloody vehicle in Melrose Park. (Author's collection.)

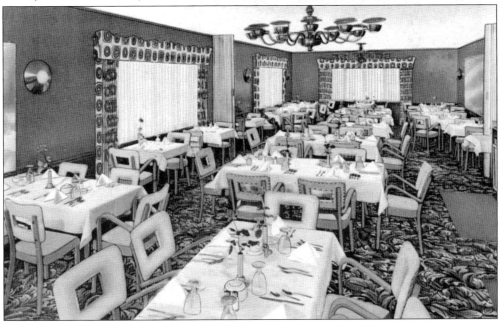

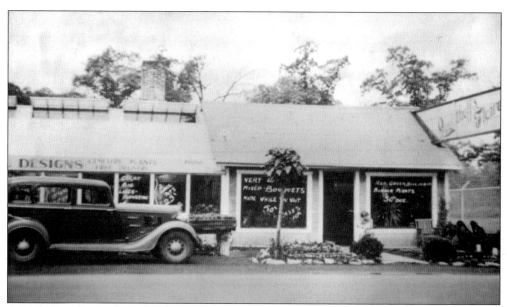

Adolph Quasthoff, whose family were florists back in Germany, opened a floral shop in 1920 by Rosehill Cemetery in Chicago. By 1935, he had opened a shop in River Grove, shown here. This shop was located where the Metra station parking lot is on the west side of Thatcher South of St. Joseph's Cemetery. The barbed-wire fence is still there, minus the barbs. (Harry Schneider.)

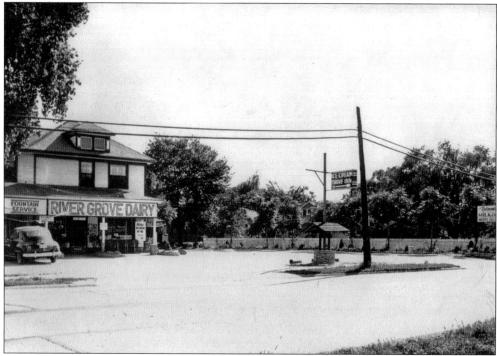

The River Grove Dairy, not to be confused with the Village Dairy, was located at 8637 Grand Avenue. Herman Schocke was the proprietor until his death. His daughter-in-law Bella Schocke served as the River Grove police matron and was quite a good shot with her pistol. She entered at least one shooting competition and was the only female entrant. (Franklin Park Library.)

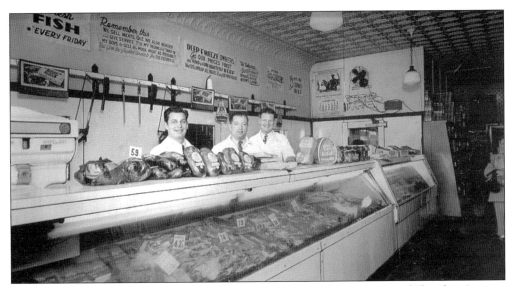

The Stein family had a grocery store on the south side of Grand Avenue east of Thatcher Avenue. They moved across the street and took over the deli area of the A&P store. Seen at the counter are, from left to right, Les, Saul (their father), and brother Frank. The brothers later bought the store and it became the Stein Brothers Meat Market. Frank was heavily involved in community organizations throughout his life. (RGHC.)

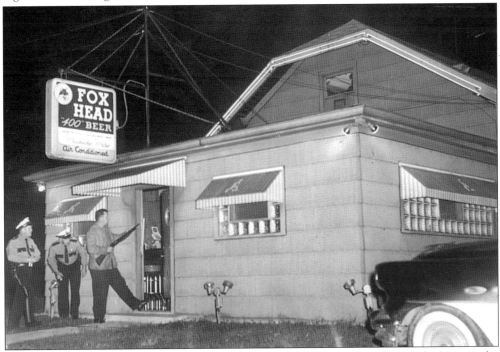

In this 1957 *Chicago Tribune* photograph, police chief O'Hallen is seen bravely kicking in the door of the Triangle Inn at 2500 North Thatcher Avenue in the era before bulletproof jackets. This concluded a two-hour siege of the notorious establishment after a raid resulted in two federal drug agents being shot along with a suspect. Both agents recovered. The tavern had also once been fined for having slot machines. (VA.)

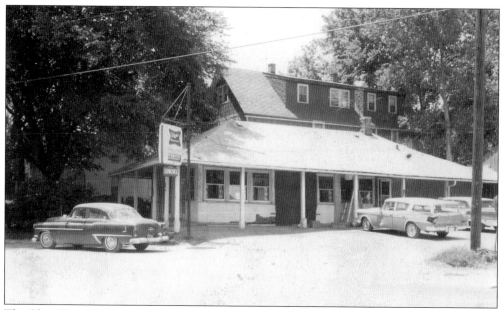

The Glass House is shown here as it appeared when first purchased by Stanley and Rose Sacharski in 1964. In the 1930s, when owned by Marshall Thorsen, it had more of a Floridian feel. The dining room had a glass roof with ferns dangling from hanging baskets above the tables. (Hala Kahiki family.)

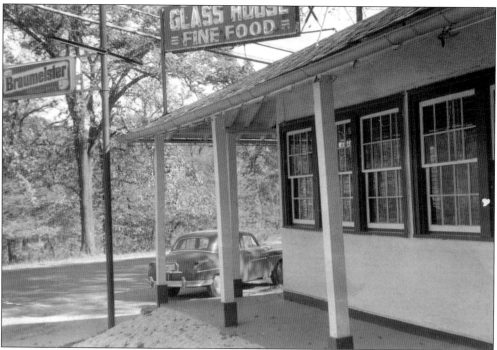

The Glass House must have been a window washer's delight. However, one of the first things Stanley and Rose Sacharski did was to close in the porch area and covered the building with rough cedar shake shingles, a theme that they added to all their River Road properties. This view is looking toward River Road at what is now the entrance to the Hala Kahiki. (Hala Kahiki family.)

Almost immediate after Stanley and Rose Sacharski moved to River Grove and purchased the Glass House, they set about converting it into the Hala Kahiki, as it is known today. The name, which means "pineapple" in Hawaiian, has adorned the property since 1964. Grandson Jim Oppendisano now owns the family business. (Hala Kahiki family.)

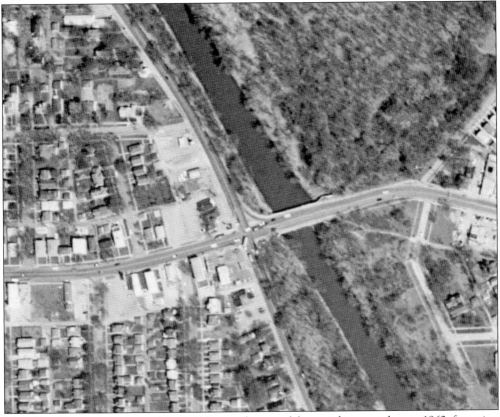

The Glass House is the long white building at the top of the aerial image taken in 1962, featuring the intersection of Grand Avenue and River Road. Other highlights are the old Gene & Jude's just above the Otto's/Thirsty Whale at the northwest corner of the intersection. Just above that is the Cock Robin, which was once known as Prince Castle. Also, a couple of homes can be seen on River Terrace that were later cleared to create River Front Park. (Historicaerials.com.)

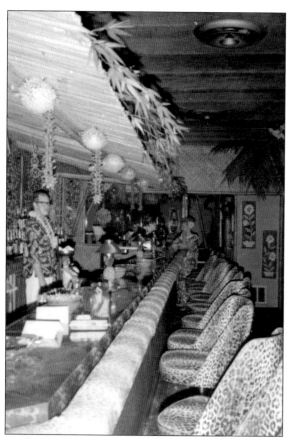

The bar of the Hala Kahiki looks strikingly similar today as in this photograph taken in the mid-1960s. However, the scene was quite different in 1946, when two armed thugs shot and killed Thomas Casey, then owner of the Glass House. The pair netted only $90 and it was suspected at the time that Casey knew his killers as he was heard to say, "Swell, Pals" just before being shot. The business was sold a short time later, but remained the Glass House for several more years. (Hala Kahiki family.)

This 1997 photograph shows the result of almost 30 years of labor that transformed a regular River Grove backyard into a tropical getaway. Rose would tell Stanley what she wanted, and he would figure a way to do it. Oaks, elms, and maples, rather than palm trees, cast their shade over the courtyard, but there is not anywhere else quite like it in the area. (Hala Kahiki family.)

Blue Horizon Motel

MOTEL

SOUTHWEST CORNER BELMONT AVE. AND RIVER RD.

RIVER GROVE, ILLINOIS

5 MINUTES TO CHICAGO CITY LIMITS

This postcard for the Blue Horizon Motel apparently shows some kind of architectural model with a few matchbox cars around it rather than the real thing. The motel, once owned by Arthur Zimbroff, opened in the early 1960s. It still stands but now is under the Super 8 banner. (VA.)

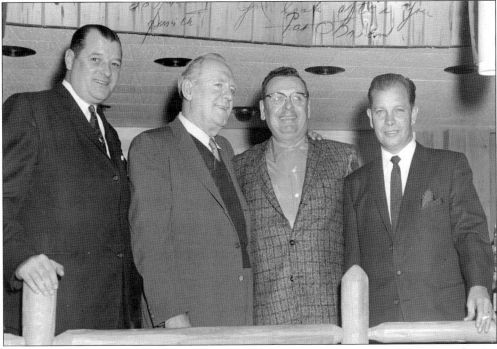

Actor Pat O'Brien (second from left), most famously known for portraying Knute Rockne in *Knute Rockne, All American* (among over 100 screen credits), signed this photograph for Harry Smith (third from left). The actor and businessman was staying at the Blue Horizon Motel on River Road and Belmont Avenue. He may have been in town for a business trip, to perform his one-man show, or to appear at some local nightclub. (Harry Smith Jr.)

In 1970, the school district purchased the Ken Idle house (shown here) at 8445 Grand Avenue, once owned by first president Paul Lau, along with the old Kurlin Building at 8423 Grand Avenue, which was home to Johns Barbershop and the Leyden Currency Exchange, and all of the land adjacent to the River Grove School. The house was demolished in 1974 after failed attempts to sell. The district had hoped that a purchaser would move it. (RGHC.)

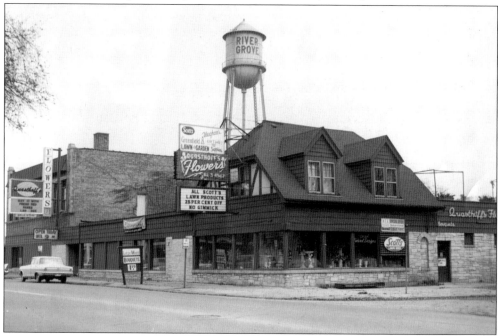

Proximity to the cemeteries provided a steady stream of customers, and by October 1965, Quasthoff's Flowers had expanded into the old Illinois Bell building just north of the main Bavarian/Tudor–style storefront in the shadow of the landmark water tower. Quasthoff's Flowers closed in January 2008, after which the building was torn down. Quasthoff's returned to River Grove in 2015 at 8125 Grand Avenue. (Harry Schneider.)

Gene Mormino started a hotdog stand in 1946 at Polk Street and Western Avenue but lost the business three years later in a card game. Then in 1950, he teamed up with Jude DeSantis and started a new stand in a building on River Road just north of the current site and seen on the right. The building did not even have a name on it, just "Red Hots with French fries." (Gene & Jude's.)

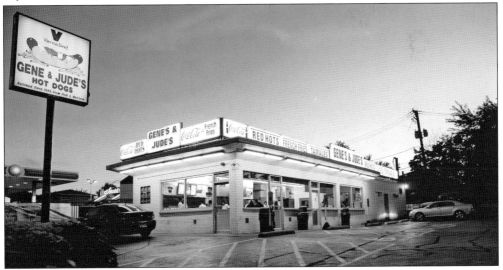

Gene & Jude's famous white brick building at 2720 North River Road has been a landmark since the 1960s. When the signs were affixed to the building, it was apparent the name was spelled wrong—with an apostrophe. Gene just said, "Leave it." The restaurant only sells its award-winning hot dogs, double dogs, tamales, and fries, but it does not offer ketchup. (Gene & Jude's.)

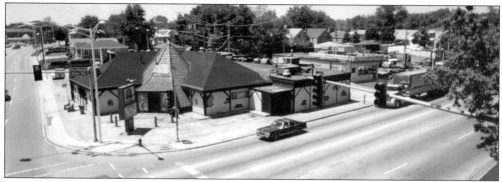

This aerial photograph taken by Brent Leder shows the Thirsty Whale shortly before it was torn down. The historic club originally known as Otto's, then the Red Steer, and finally the Thirsty Whale played hosts to such nationally known bands as Blue Oyster Cult, Foghat, Survivor, and Rock & Roll Hall of Famers Cheap Trick from 1975 until 1996. (RGHC.)

While many national acts would stop in River Grove when playing in Chicago, the club also gave many young local bands a chance to gain a following and experience playing before an audience. In this rare shot from the stage, taken by Tommy Gunn guitarist Marty Kelly, the exuberance of the crowd is evident. (Marty Kelly.)

This advertisement for the Thirsty Whale is from the time denim and leather ruled the day. It represents but a small sampling of the bands that appeared at the Thirsty Whale from the late 1980s until it closed its doors on June 2, 1996. Local headbangers would pick up the *Illinois Entertainer* at Rolling Stones and get the latest roundup of the acts scheduled to play the "Whale." (VA.)

The River Grove Inn, located at Grand Avenue and Oak Street, will look familiar to keen-eyed readers. The building is seen on page 25 in its days as a tavern owned by Andrew Schlereth and Louisa Allendorfer. Asphalt siding was installed over the wood siding. Four condominium buildings now occupy the site at 8553 Grand Avenue and the three properties to the east. (RGHC.)

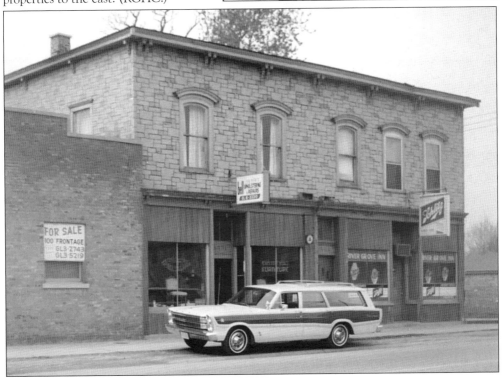

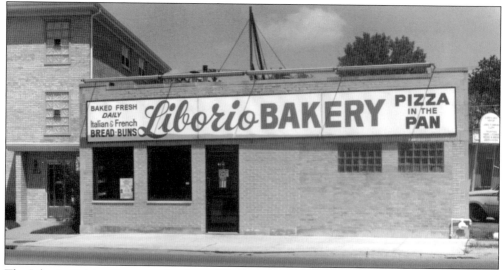

The Liborio Baking Company has been filling the neighborhood with the comforting smell of baked bread since 1967. That is when Liborio Mugnolo opened the bakery that carries his name at 8212 Grand Avenue. His nephew Andrea Letizia and his wife, Rita, have owned and operated the business since 1981. In this true family business, their children Maria, Dominic, and Tony support the daily operations. The business has expanded over the years and is known for its bread, cookies, and famous pizza bread. (Liborio Baking Company.)

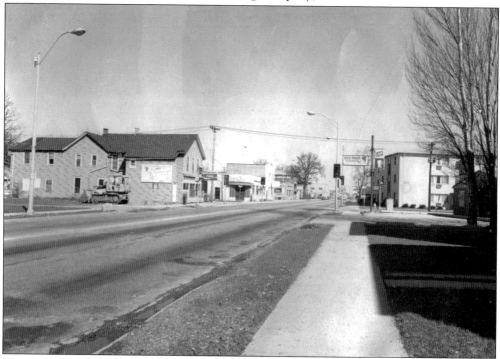

The final days of the Village Dairy are captured in this image. The building (on left), which was one of the oldest in the village, was demolished in 1976 to make room for more apartment buildings. The Idle Hour Lounge, located at 8601 Grand Avenue, is now home to the Grand Stop Bar & Grill. The Village Dairy building can be seen in the photograph on page 27. (Mario Novelli.)

The North Avenue Outdoor Theatre, which opened in 1948, was a companion to the Harlem Avenue Outdoor Theater, which was built in the Harlem/Irving Plaza area. The North Avenue drive-in was heralded as a new, modern outdoor theater with wider ramps for wider vehicles and a new, angled screen for better viewing. It even featured midnight showings. (RGHC.)

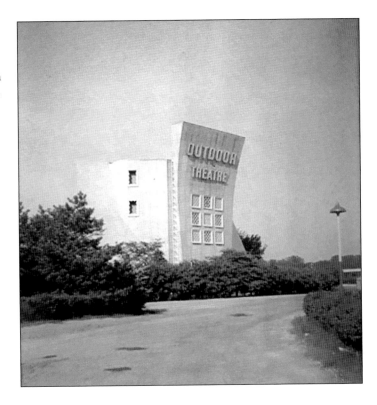

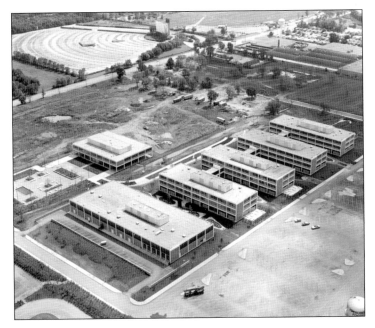

This aerial view, from high above Consolidated Foods, faces southeast. Taken early in the construction of Triton College, the image shows the entire drive-in theater. The college purchased the 20-acre theater site east of Fifth Avenue in 1968. It would become home to the school's athletic fields and parking lot. Just north of the old theater site are the Triton College botanical gardens, which feature a statue from the 1893 Chicago World's Fair. (Triton College.)

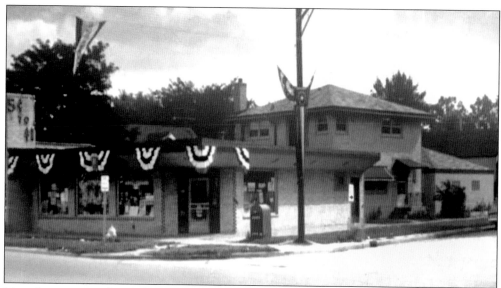

Many longtime residents of River Grove will get a twinkle in their eyes at the very mention of Hank's. The 5¢ to a $1 store was a place of young children's dreams. The store was located at 8225 West Grand Avenue, and the structure is now home to a dentist office. In the photograph, Hank's is festooned in bunting for the 1963 Diamond Jubilee. (VA.)

Larry's Auto Parts, at 8007 West Grand Avenue, has been at the eastern gateway to the community since 1983. Another longtime business is the neighboring West Harlem Supply Company, at 8025 West Grand Avenue. West Harlem has been in business since 1970. Prior to that, it was known as Modern Gardens. Note the current "Welcome to River Grove" sign. (Author's collection.)

Six

Same Place, Different Time

The passing of years can have strange effects on a person's memory. People often think about a time or place and imagine it much differently than it actually was. Photographs do not change, they may fade or become brittle perhaps or even suffer water damage, but when viewed they can bring back a flood of memories. The preceding chapters may bring back fond memories of places and people who may no longer be here yet always remain a part of those connected to River Grove. Places such as Augies Bike Shop, now the Zen Den, or the site of Action Health Club, now Ada's European Market & Deli, for example.

River Grove has come a long way in its 130 years of existence. From vast farms and fertile prairie emerged businesses, homes, schools and churches. Quiet, sleepy crossroads have become major intersections. Landmarks like the old water tower outlive their usefulness. The public schools have seen continued growth and expansion and would be unrecognizable to earlier generations.

Other changes are found among the business districts, where storefronts and vacant lots once stood are now apartments and condominiums. Many familiar buildings fell to the wrecking ball. The Senf's Hall location first became a gas station then a strip mall, the Thirsty Whale became a gas station/McDonald's, and the bowling alley site will now feature high-end apartments. The 22-acre site of the former Wilson Sporting Goods facility that later housed the Follett Company is being redeveloped by Go To Logistics, which is building a new 225,000-square-foot warehouse facility. Other places vanish from sight, but the memories remain.

The forest along Des Plaines River was once described as consisting of willows first, then river maple, cottonwood, and ash. Sadly, most of the ash trees have died because of the emerald ash borer. Today, the riverbanks remain a critical pathway for migratory birds and one can still walk the trails first trampled by hooves and moccasins.

Yet other things stand the test of time and somehow adapt to the times. River Grove has a considerable number of 19th-century farmhouses. They may look a bit different; however, they remain the heart of the village. Over 130 years, some things change and change again. This final chapter attempts to reacquaint the reader with a place or location that he or she may have not thought about in many years.

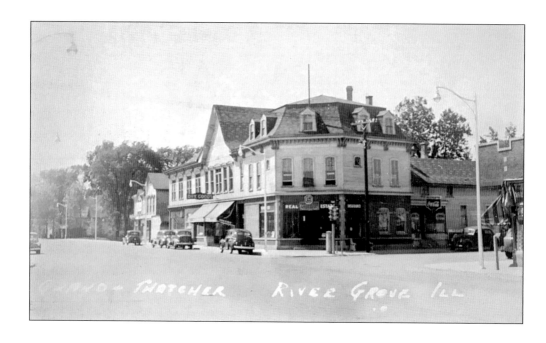

By the 1940s, when this photograph was taken, Senf's Hall had already gone through several changes (see page 21). The elaborate fretwork below the vaulted roof had been removed, and the stable area had been closed in. The corner no longer featured a restaurant and had become a real estate office. After fire destroyed the building in 1963, it was replaced by a gas station. The River Grove Plaza now sits on the site and is home to several businesses, including Pops Place, a salon, and a T-Mobile store. The large Illinois Bell building is just to the left of the T-Mobile store. (Above, RGHC; below, author's collection.)

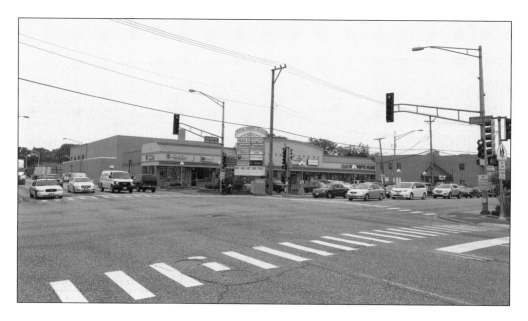

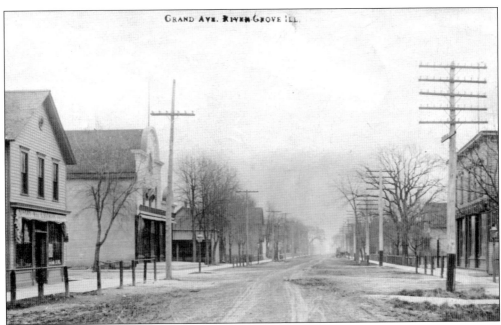

This early postcard shows River Grove's main street, Grand Avenue, in a view looking east from Oak Street. The road was basically a one-lane dirt path. The trails left by the wagon wheels can clearly be seen. Almost every building had a hitching rail out front so that patrons could tie up a horse and buggy or just a horse. Postcards were the Facebook and Twitter of their day. People could send a photograph of their hometown to relatives all across the country for a penny. The large tree in the modern photograph is probably in the above photograph as well. It is one of the oldest along Grand Avenue. The Grand Stop in the image below was known as the Idle Hour Lounge for many years. (Above, RGHC; below, author's collection.)

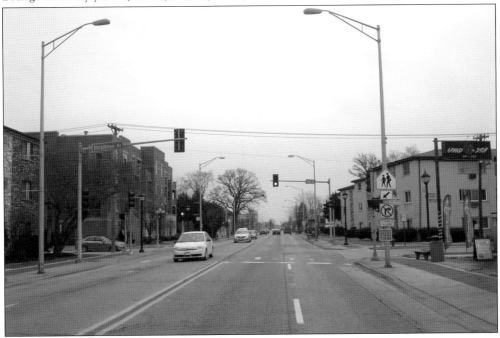

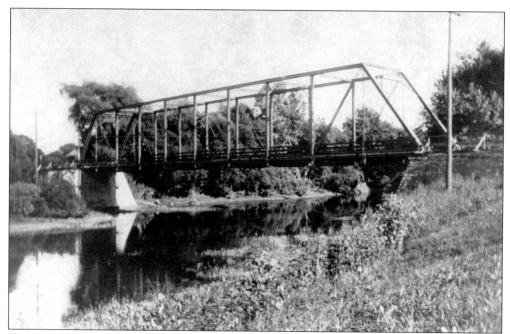

A series of bridges have been spanned the river at Grand Avenue. The first, the Walker Bridge, was built in 1834 when Grand Avenue was known as Whiskey Point Road. The bridge in the above image was built in 1882 and received many improvements in 1899. The River Bridge, as it was known, served until 1922 when the current bridge was built. A unique equestrian underpass was added to the east side in 1936. Once used by horseback riders, it is now used by bicyclists and joggers. The bridge has been refurbished and widened from 27 feet to 40 feet. It serves as the finish line for the annual charity duck race, which starts upstream at the railroad bridge. With views looking southeast, these images were both taken from the west side of the river. (Above, RGHC; below, author's collection.)

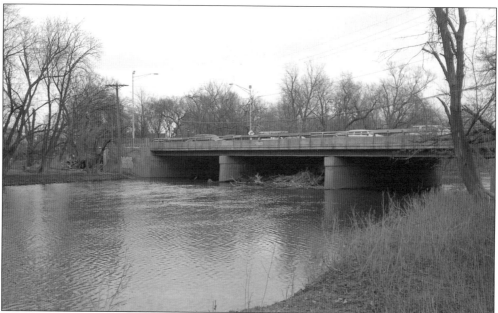

The River Grove Historic House at 8455 West Grand Avenue, once owned by Henry Buckman and Bertha Senf Buckman, was built in 1876. At right is how it looked in 1972, and below is how it looks in 2018. Some might argue the mist in the earlier picture is evidence of paranormal spiritual activity. Also seen to the left of the historic house is the former home of the first president of River Grove, Paul Lau. The River Grove Historical Commission has been restoring the former Buckman farmhouse to its original 19th-century appearance and has procured some of the original furnishings. The house was placed in the National Register of Historic Places in 1995. There are several local homes standing that predate the village. Among them, 8941 Chestnut Street predates the historic house by three years. There are over twenty 19th-century homes in the village. (Right, RGHC; below, author's collection.)

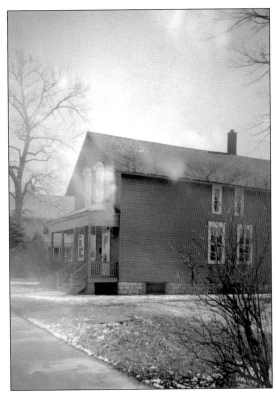

In 1928, a new modern brick village hall was constructed at Wrightwood and Thatcher Avenues on land donated to the village by the Women's Club. The new building constructed by local contractor George Hansen replaced the old wooden structure on Auxplaines Street that had served for 38 years. The 1928 building is still home to the fire department. In the 1970s, after the village offices moved a few doors north, a structure housing the antique fire pumper was placed in front of the old main entrance. A new entrance was added to the northern portion of the structure. The building housed the courtroom for some time, but it was later moved to a new edifice. (Above, Franklin Park Library; below, author's collection.)

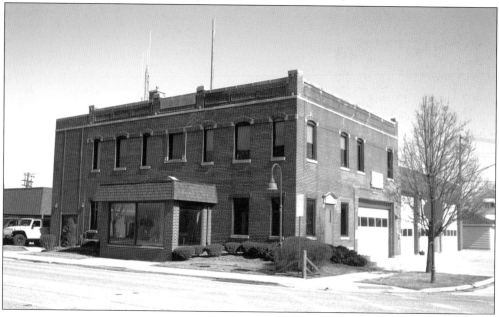

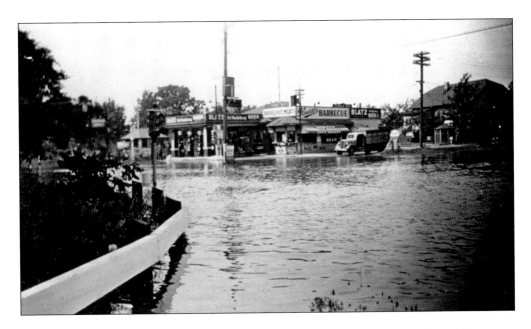

Flooding of the Des Plaines River is a somewhat frequent experience that coincides with the spring thaw and reflects the seemingly intensifying rainstorms of the past several years. The photograph above is of the intersection of Grand and Thatcher Avenues in 1938. The picture below is from the summer of 2017. Even with the preventative measures that have been made, such as building a new North Avenue bridge and the removal of the Hoffman Dam in Riverside, flooding remains a concern. Owners of the Dunkin' Donuts seen below took flooding into account when they built their two-story building. The 2017 annual plastic duck races had to be postponed due to flood conditions. (Above, Franklin Park Library; below, author's collection.)

In 1976, the village needed more room for a modern police station and administrative offices that would be readily accessible to people with special needs. The village acquired the building at 2621 Thatcher Avenue and refurbished the complex to also include a civic center. The old village hall still houses the fire department and has meeting rooms. The three flagpoles out in front of the new village hall stand vigil over monuments dedicated to local veterans. The center monument was made to honor four men who gave their lives serving the country in World War II; their names are George Finley, Louis Kyriazopulos, Pasqaule Pizzirulli, and Christen Hansen. The other two monuments are to veterans of the Vietnam War (left) and the Korean War. (Above, RGHC; below, author's collection.)

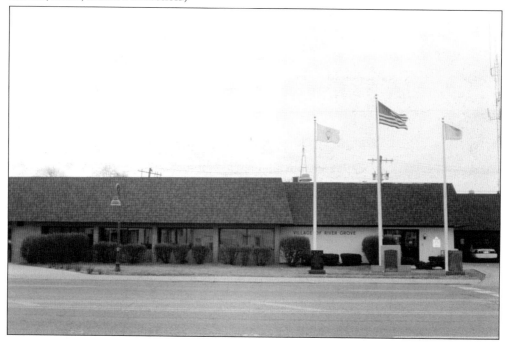

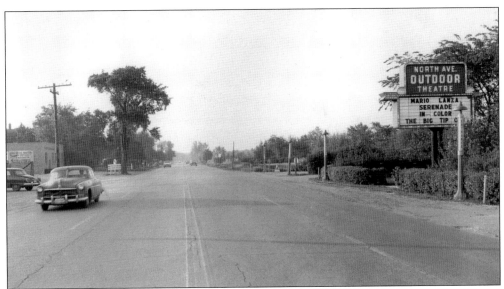

The North Avenue Outdoor Theatre was one of 120 drive-in movie theaters located in Illinois in the 1950s. The theater, which could hold 1,000 cars, was located on the east side of Fifth Avenue where the Triton College athletic fields and the Robert Collins building stand today. The theater opened on August 6, 1948, and showed its last movie in 1973. Only about 10 drive-ins are still open in Illinois. The scene today is much different. The entertainment area once included Kiddieland Amusement Park, Sunset Stables, Golf land Driving Range, miniature golf, go-karts, and a roller rink. Today, are all closed. A Costco is on the Kiddieland site, and the other areas have been repurposed. (Above, RGHC; below, author's collection.)

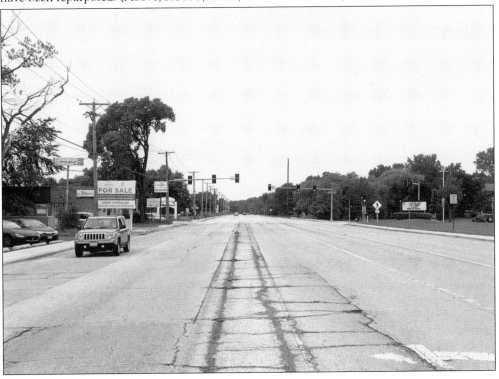

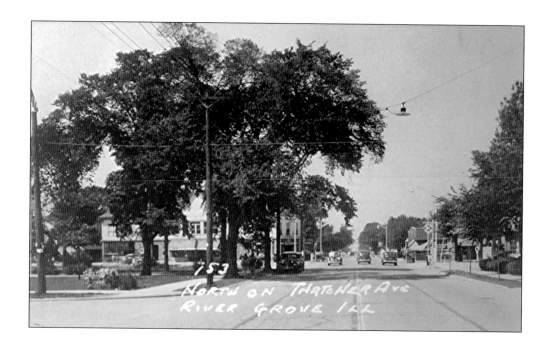

The above image was likely taken in the 1940s based on the appearance of the autos. The view looks north on Thatcher Avenue from River Grove Avenue. The large canopies of oak and elm trees casting their cooling shade is the most striking difference in the images. Virtually the only thing consistent between the views is the road itself, but even that has changed. The widening of Thatcher Avenue left little parkway for trees. In the picture above, Senf's Hall can be seen on the left and the awning over Johnson's Drugstore and the Sinclair Gas station on the right. In the modern photograph, the River Grove School is the large structure seen on the left and Triton Towers is the tall structure seen on the right. (Above, RGHC; below, author's collection.)

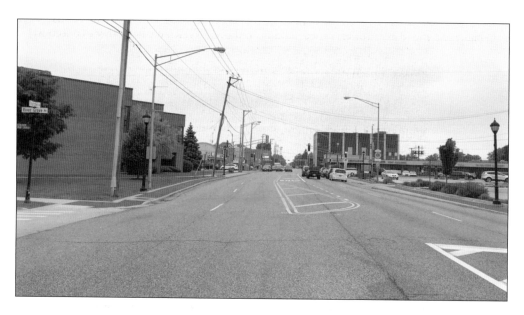

The aerial photograph above, taken in 1950, is a bird's-eye view looking west along Grand Avenue. The large building in the center is Idle Motors. That structure, later Polk Brothers, was demolished, and River Grove School expanded on that site. The Des Plaines River is the wooded line extending all across the photograph. Note the vast open land at the top of the image. The contrast in 2018 is quite apparent, with much more open space. In the center of the modern photograph, the 1928 River Grove School can be seen surrounded by the additions. Other areas of note are the three strip malls and the Triton Towers office building. (Above, RGHC; below, author's collection.)

DISCOVER THOUSANDS OF LOCAL HISTORY BOOKS FEATURING MILLIONS OF VINTAGE IMAGES

Arcadia Publishing, the leading local history publisher in the United States, is committed to making history accessible and meaningful through publishing books that celebrate and preserve the heritage of America's people and places.

Find more books like this at
www.arcadiapublishing.com

Search for your hometown history, your old stomping grounds, and even your favorite sports team.

Consistent with our mission to preserve history on a local level, this book was printed in South Carolina on American-made paper and manufactured entirely in the United States. Products carrying the accredited Forest Stewardship Council (FSC) label are printed on 100 percent FSC-certified paper.

MADE IN THE USA